GORDALE SCAR

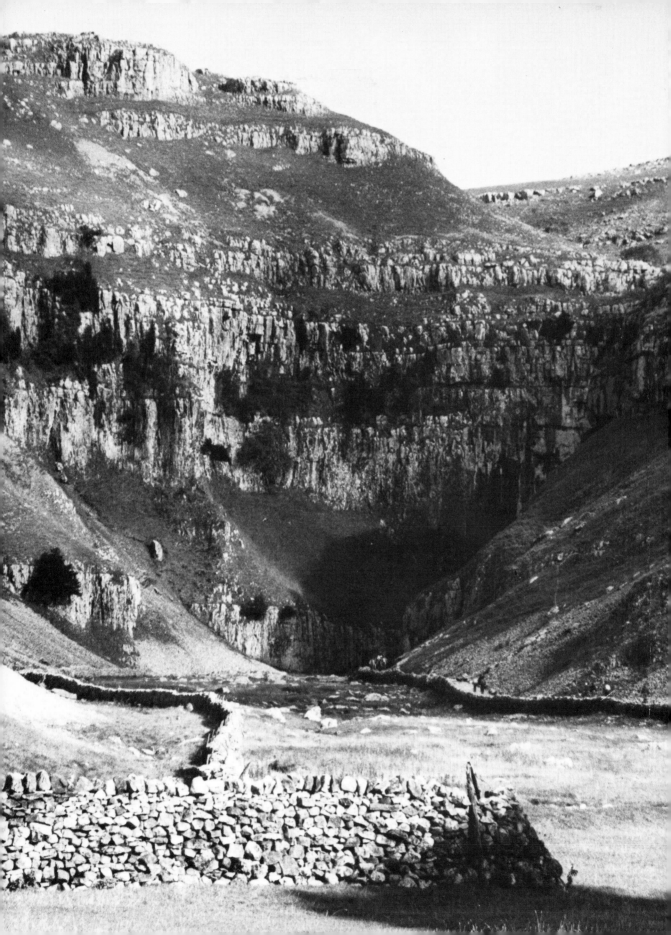

James Ward's
GORDALE SCAR
An Essay in the Sublime

EDWARD J. NYGREN

The Tate Gallery

Photographs of the site, Gordale Scar,
(fig.11[a–d]), by Robert Claxton

Photographs for the following works are reproduced
through the Courtesy of the Paul Mellon Center
for Studies in British Art: fig.10, and Cat.nos 3, 6, 7,
10, 11, 13, 22, 23, 25, 28, and 29

ISBN 0 905005 93 7
Published by order of the Trustees 1982
for the exhibition of 3 November 1982 – 2 January 1983
Copyright © 1982 The Tate Gallery

Published by the Tate Gallery Publications Department
Millbank, London SW1P 4RG
Designed by Caroline Johnston
Printed by The Hillingdon Press, Uxbridge, Middlesex

1002331416

Contents

cover
James Ward
Gordale Scar 1811
(detail, Cat.no.35)

frontispiece
Gordale Scar, 1981
Photograph by Robert Claxton

FOREWORD

On account of its size and subject, James Ward's 'Gordale Scar' is one of the most spectacular paintings in the Tate Gallery collection – a monument to the Romantic passion for the sublime, and to the ambitions and confidence of British painters in the early years of the nineteenth century. No wonder Delacroix and Géricault were impressed by what they saw when they came to England as young men, and Ward was one of the artists whose work Géricault particularly admired.

Ward himself was a colourful character – megalomaniac and quarrelsome, the son of a drunken cockney greengrocer, he lived to the great age of ninety. His last days were difficult: perhaps it is not surprising that as a very old man in 1852 he should tell his daughter that he now hated art, and, more pertinent to this present occasion, he added: 'To me now, an exhibition of pictures is disgusting – and to read anything about pictures in the newspapers and any-where else, makes me sick . . .' (but then he was not thinking of his own work).

Ward's own painting has a distinctive kind of crustiness, a gnarled, dry, fierce, tight, crabby quality that is somehow common to everything he lights upon, whether it be the horses and fighting animals, the rocks of tree-trunks, huntsmen and shepherds or the prophet Job. He is certainly no rival to his great contemporary Turner, but there is a fascination about James Ward that gives his best work a memorability and power.

Whether Ward's achievement would justify today a fullscale retrospective is arguable; but his response to Gordale Scar, that remarkable cliff-like natural feature in the northern Pennines, was so overwhelming that a more limited presentation is certainly appropriate. This small exhibition traces the origins and genesis of the Tate's picture, through the many studies that Ward made, both of animals and the landscape itself. These preparatory works are shown in the context of some other paintings.

We are most grateful to Edward J. Nygren, Curator of Collections at the Corcoran Gallery of Art in Washington, D.C., for making the selection and writing the catalogue. Not enough has been published about Ward, and this is a major contribution. All the lenders have our sincere thanks for their generosity – without them this exhibition would not have taken place.

Alan Bowness
Director

PREFACE

It is not often that the development of a work of art from genesis to completion can be documented with numerous studies and sketches. When such a body of material can be assembled, it provides a rare opportunity to gain insight into the very nature of the artistic process. For 'Gordale Scar', the movement from initial sketch to final painting is made more dramatic by the extraordinary difference in scale between the first small study and the monumental finished work of art. The sketches Ward quickly executed on the spot give evidence of the artist's hand being his antenna on the world. While some were incorporated in the ultimate composition, many were drawn without this intention in mind and reveal an artist almost automatically recording sensory perceptions as he tries to absorb the essence of a place. A few of the studies also show how Ward (and he was not alone in this practice) did not limit himself to sketches made at the site which was to be the subject of the painting, but turned to drawings done at other times and locations for compositional motifs.

'Gordale Scar' offers yet another opportunity. It provides the chance to experience directly what was meant at the time by the sublime in art, which along with the beautiful and the picturesque was one of the reigning aesthetic concepts of the day. Through Ward's sketches and modern photographs of the actual Scar, the viewer can see how the artist consciously manipulated topography to achieve the statement he desired. The sublime effect Ward sought in 'Gordale Scar' becomes all the more apparent when the painting is compared with works by the same artist exemplifying the beautiful and the picturesque. The differences between these abstract concepts are not easy to comprehend in part because the terms, despite repeated attempts to isolate their identifying characteristics, were often endowed by the writers of that period with similar traits. While it is unlikely that this exhibition will eliminate once and for all the ambiguity surrounding these words, it does try to present a simplified visual demonstration of them by focusing on what arguably are three quintessential works.

The idea for this exhibition grew out of my dissertation on James Ward for a doctorate at Yale University. An appointment as a Chester Dale Fellow of the National Gallery of Art (Washington, D.C.) permitted me to conduct research in England. In addition, my work was supported on two occasions by grants from the Paul Mellon Centre for Studies in British Art (London), which supplied photographs of many of the items included in the exhibition. The Tate has also contributed toward my research.

No exhibition could occur without the cooperation of the owners of works

of art. A list of lenders appears elsewhere, but I wish to take this opportunity to thank them for their support.

This catalogue has been dedicated to Prudence Summerhayes and is also in memory of Professor and Mrs Robert Werner. Prudence Summerhayes, a descendant of the artist who has written perceptively on her ancestor, has been especially generous with her time and collection. Professor Werner, another descendant, and his wife were supportive of my work through its many stages. The full cooperation of their daughter, Mme Arnold, was essential to the success of this project. Anthony Reed, a fellow enthusiast for Ward, has lent his good eyes and keen sense to me on many occasions as well as several works to this exhibition. Paul Mellon is, in a way, ultimately responsible for the show since it was upon viewing his collection that I decided to do my dissertation on Ward.

While it is impossible to mention all of those who helped me in planning the exhibition and preparing the catalogue, I want to thank especially my friend, Robert Claxton, who shared a memorable pilgrimage to Gordale, and to whom I am indebted for the excellent photographs of the site reproduced herein. Among the members of the Tate staff, Martin Butlin deserves credit for encouraging me to undertake this project; Caroline Odgers and Ruth Rattenbury, for overseeing the exhibition and installation. Mrs Morton of the Yorkshire Archaeological Society was especially helpful in finding manuscript material and locating prints.

A special acknowledgement is due to Colonel E. J. S. Ward and his late wife, Susan. The memory of many days spent enjoying their warm hospitality while leisurely studying their extensive collection of drawings and paintings will remain with me always.

Gordale Scar – An Essay in the Sublime

Gordale Scar, near Settle in West Yorkshire, presents to the modern tourist, as it did to James Ward and his contemporaries, an awesome sight. Towering limestone walls turn a simple valley into an enormous amphitheatre for the natural drama that is played without cease at the far end. Hidden from the curious by a massive outcropping until they are virtually upon it, Gordale Beck bursts through its rocky passage and plunges down a gorge. Spent by its fall, the brook meanders through a field before it joins with the River Aire. Some years the cataract is little more than a vigorous stream of falling water, but after a long period of rain, this stream can become a broad torrent, smashing against huge rocks on its precipitous descent to the riverbed below.

Today's visitor travels an easy, well-kept path from the paved road to the cataract. The journey in Ward's day was more arduous, but it could be made on a day's outing from nearby Settle by the seasoned enthusiast in quest of the natural sublime. Undoubtedly the site has lost some of its power because of its accessibility to tourists bussed in by the hundreds every year, but Gordale Scar still commands respect and admiration, even from those whose eyes have seen far grander natural wonders.

When James Ward visited Gordale Scar in the summer of 1811, the site was known to lovers of sublime scenery. For the past half-century, Britain had been crisscrossed by numerous travellers, who avidly sought its scenic beauties and wrote ecstatically of their experiences. Artists too, professional as well as amateur, journeyed the length and breadth of the country, making countless sketches of which only a few emerged from the studio as finished drawings or landscape paintings.

Although Gordale may not have been as frequently visited as the Lake District or parts of Wales, it attracted its share of dedicated admirers. Among the first to record his reactions to the Scar was the poet, Thomas Gray. Gray visited the area in October of 1769 on what he described as a 'gloomy uncomfortable day well suited [to] the savage aspect of the place.'[1] His observations were published in 1775, a few years after his death:

The rock on the left rises perpendicular with stubbed yew-trees and shrubs, staring from its side to the height of at least 300 feet; but those are not the things: it is that to the right under which you stand to see the fall, that forms the principle horror of the place. From its very base it begins to slope forwards over you in one block and solid mass without any crevice in its surface and overshadows half the area below with its

dreadful canopy I stayed there (not without shuddering) a quarter of an hour, and thought my trouble richly paid, for the impression will last for life[2]

The canopy, still very much in evidence, appears in one of the earliest portrayals of the Scar (fig.1).[3] Ward himself drew it (Cat.no.10) but this feature is hidden in the gloom of the final painting.

Gray's enthusiasm was shared by other visitors to the site. Two years after the publication of *Journal to the Lakes*, William Bray echoed Gray's sentiments in his *Sketch of a Tour into Derbyshire and Yorkshire* (1777). But it was in the first decade of the nineteenth century, shortly before Ward's visit, that the Scar received several glowing descriptions.[4] Edward Dayes, who considered it 'one of the grandest spectacles in nature,' laced his lengthy comment with phrases often applied at the time to wild scenery:

> Good heavens, what a scene, how awful! how sublime! Imagine blocks
> of lime-stone rising to the immense height of two hundred yards, and
> in some places projecting upwards of twenty over their bases; add to
> this the roaring of the cataract, and the sullen murmurs of the wind that
> howls around; and something like an idea of the savage aspect of this
> place may be conceived.

Dayes was particularly enthusiastic about the hole through which the stream issued:

> This is, perhaps, the finest part of the whole place, and should by no
> means be neglected, however difficult the ascent to it may be.

And he commented on the artistic inspiration aroused by the 'immensity and horror' of the spot, remarking that 'the very soul of Salvator Rosa would hover over these regions of confusion.'[5] An attempt to capture the Salvator Rosa-like quality of the site is evident in the various portrayals (figs 1-4) with the rocks of the ravine towering over the visitors as they confront the waterfall.

Of the other two accounts, Thomas Whitaker's *The History and Antiquities of Craven* was the more ambitious publication. Focusing on the history of a small area, it deals with many subjects, including the wild white cattle of Lord Ribblesdale, the owner of Gordale who commissioned Ward to paint the picture. It seems likely that Ward saw Whitaker's book at Gisburn Park, the Ribblesdale estate. And perhaps it is more than coincidence that Ward's painting, like Whitaker's description, emphasizes the approach to the cataract as much as the waterfall itself.

The paucity of artistic treatments of this awesome site prior to Ward's tends to substantiate the well-known story that Sir George Beaumont, a landscape artist and arbiter of taste, pronounced Gordale unpaintable.[6]

Whitaker, too, felt that 'the pencil, as well as the pen has hitherto failed in representing this astonishing scene,'[7] noting as possible exceptions Gray's eulogy and the design by Reverend Griffith in his own book (fig.2). Ward, who delighted in such challenges, reportedly undertook the project in part because of Sir George's pronouncement. It remains to be seen if Ward proved Sir George wrong.

Anyone familiar with the actual site realizes that the artist took great liberties with the topography in his composition. Knowing what Ward did and why is critical to seeing 'Gordale Scar' (fig.5) as an essay in the sublime.

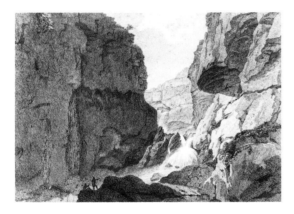

fig.1 John Cawthorn, Jr, 'View of Gordale Scar', 1808
Yorkshire Archaeological Society

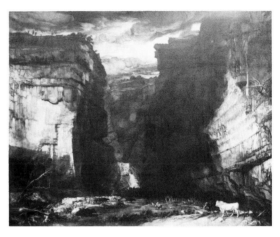

fig.5 James Ward, 'Gordale Scar', *Tate Gallery* [Cat.no.35]

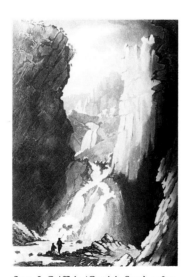

fig.2 J. Griffith, 'Gordale Scar', *c.*1805
Yorkshire Archaeological Society

fig.3 William Westall, 'Gordale
Scar', 1818 *Fitzwilliam Museum*

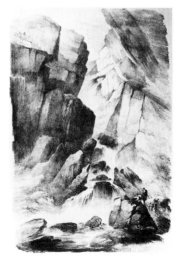

fig.4 George Nicholson, 'Gordale Scar'
1822 *Yorkshire Archaeological Society*

It should be remembered, however, that the liberties he took would have been condoned by his contemporaries, including Sir George Beaumont, for the slavish imitation of nature was considered incompatible with an elevated, poetic treatment of landscape.[8]

James Ward (1769-1859) was in the prime of his career when he accepted the commission from Lord Ribblesdale to paint 'Gordale Scar'. Elected an associate of the Royal Academy in 1807, he was made a full Academician in February 1811, just months before his first and only visit to Gisburn. Behind him were years of struggle for recognition; before him, a decade of enormous productivity in which he realized his full artistic potential and experienced terrible professional disappointment. An extremely uneven artist, Ward produced many paintings of great visual power throughout his long career. Among these 'Gordale Scar' ranks as one of his masterpieces although it neither pleased his patron nor met with critical acclaim.[9]

Hailed as the greatest animal painter of his day, Ward was well qualified to undertake a commission that combined the portrayal of a dramatic landscape with depictions of cattle. From the late 1790s onward, he was well known for his cattle portraits. Around the turn of the century, Ward became involved in a project, supported by Boydell the print publisher, to record the various breeds of livestock in Britain.[10] Although the project was never completed due to Boydell's financial problems, Ward became a master at the delineation of cattle. His abilities in this vein were so widely acknowledged that he was frequently compared to the famous Dutch Old Master, Paulus Potter.[11] Cattle repeatedly appear in his animal subject paintings (as opposed to portraits) throughout his life.

Simultaneous with recognition as an animal painter came success as a landscape artist. In the 1790s, his highly generalized landscapes, usually the setting for some moral tale or genre scene, were reminiscent of those produced by his brother-in-law George Morland. While he had moved appreciably away from Morland by the turn of the century as a result of his study of the Old Masters, it was with 'Bulls Fighting with a View of St. Donat's in the Background' (1803, Victoria and Albert Museum) that he came into prominence as a landscape artist. This painting, as is well known, was inspired by Rubens' 'Château de Steen' (National Gallery), which had recently been acquired by Sir George Beaumont.

Although Ward's career is generally divided into two basic phases – the first dominated by Morland; the second, by Rubens – such a division oversimplifies the complex problem of what artistic influences shaped his unique vision. In the decade that separates 'Bulls Fighting' from 'Gordale Scar' echoes of other Old Masters, such as Claude Lorrain, Salvator Rosa and Titian, can be found in his work. In 1806, for example, he painted a landscape in imitation of Rembrandt's 'Mill' (National Gallery, Washington)[12] to display his mastery of *chiaroscuro*, evident as well in 'Cattle-piece' (fig.17)

of the next year. Moreover, his panoramic views frequently exhibit a debt to Thomas Girtin, whose watercolour of Cayne Waterfall, North Wales, Ward copied exactly (British Museum). Girtin also executed a watercolour of Gordale Scar (fig.6), which differs significantly from Ward's in scale and impact; nevertheless, both works are suprisingly alike in that they focus on the lower part of the cataract and exclude the upper passage praised by Dayes and included in other known representations of the site (figs 1-4). But Ward's 'Gordale Scar', whilst it may acknowledge a passing debt to other artists, is the product of his own fertile imagination and offers ample proof of his extraordinary powers.

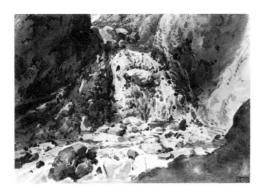

fig.6 Thomas Girtin, 'Gordale Scar', *British Museum*

Precisely when Lord Ribblesdale commissioned Ward to paint 'Gordale Scar' is not known. Although the entry in the artist's surviving *Account Book* (fig.7) is ambiguous, it can be assumed that the commitment resulted from his stay at Gisburn Park in August of 1811. The visit was probably initiated by Lord Ribblesdale's son, the Honourable Thomas Lister, an amateur artist. The year before, the young man had written glowing reports to his father of Ward's prowess as an animal painter, a field he was much interested in mastering; and in the spring of 1811, his attempt to gain access to the artist's studio on a regular basis was rebuffed.[13] Perhaps Lister persuaded his father to ask Ward to come to Gisburn Park to paint a portrait of a horse since there is some evidence that such a commission was contemplated if not executed.[14] This would have provided him with the opportunity of watching the artist work. In view of Ward's reputation as an animal painter and Lister's particular interests, it seems unlikely that the artist was invited specifically to paint Gordale. Once there, he probably heard about Sir George's opinion and warmed to the challenge. Lister would undoubtedly have seen such a commission as an entrée to Ward's London studio.

Ward arrived at Gisburn Park on 6 August 1811, after stopping at a few places on the coast and in the Midlands. He stayed until the 30th.[15] Although he may have gone to see the Scar soon after his arrival, the earliest

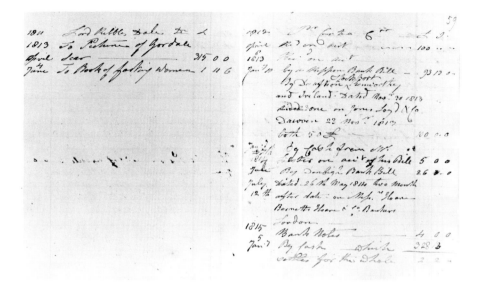

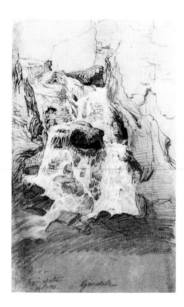

above
fig.7 James Ward, Account Book, *Mme Arnold*

left
fig.8 James Ward, 'The Falls – Gordale Scar'
Anthony Reed [Cat.no.1]

dated drawing is from 14 August (fig.8). From this close-up view of the falls, it would seem that Ward first recorded specific features of the site. By the next day, however, he had fixed the general outlines of what would prove to be the final composition (fig.9). The tentative forms of this pencil sketch indicate that it predates the chalk drawing whose inscription, added later to the covering sheet, identifies it as the 'first sketch for Gordale Scar' (fig.10). Having settled on the composition, Ward returned to the Scar on 16 and 19 August (and perhaps at other times as well during his stay) to make studies of details (Cat.nos 4, 5, 8, 9). He also spent days sketching the famous

fig.9 James Ward, 'Gordale Scar',
Mme Arnold [Cat.no.2]

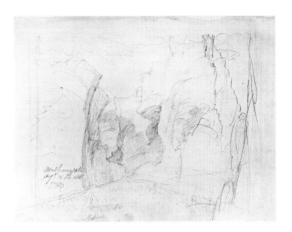

fig.10 James Ward, 'First Sketch for
Gordale Scar',
Prudence Summerhayes
[Cat.no.3]

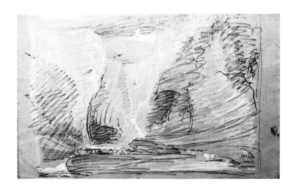

Gisburn herd of wild cattle (Cat.nos 13-19) and other points of interest
(Cat.nos 6-7).[16] Most of these studies, even those of Gordale and the cattle,
do not correspond with specific passages in the final painting, rather they
constituted a visual resource to which Ward referred as he developed the
composition. Nor did the artist limit himself to sketches done at Gisburn or
Gordale in creating the final picture. Groupings of cattle and deer made at
other places at about the same time (Cat.nos 20-27) were incorporated, and
even earlier works served as points of departure for certain elements
(Cat.nos 28-30).

The general approach was established and probably approved by Lord
Ribblesdale before Ward left Gisburn at the end of the month, but changes,
which heightened the awesome grandeur of the view, were made over three
years as the composition progressed from tentative pencil sketch through
several oil studies to the final version. The extent of Ward's artistic licence
in portraying the Scar can only be fully appreciated when the painting is
compared with the site as it actually exists. Allowing for minor geological
changes over the past 170 years and for the fact that the waterfall can vary
significantly in size and power with the season and rainfall,[17] the Scar today

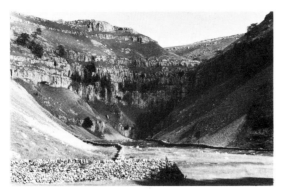 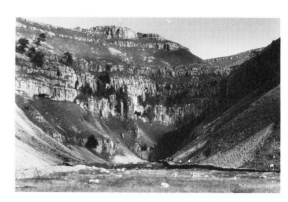

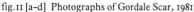

fig.11 [a–d] Photographs of Gordale Scar, 1981 [b]

has basically the same shape and size it had in Ward's time. It is obvious from photographs of the site taken as one moves through the cove from the road to the cataract (figs 11 a–d), that Ward was not interested in recording the Scar's topography but rather its psychological impact on the viewer. Even his earliest thoughts for the composition as finally executed reveal this, for at no point in approaching the waterfall is the view that Ward painted possible.

One of Ward's topographical drawings (fig.12) approximates to what can be seen of the entire cove from out in front of the Scar. However, this view is only possible from half-way up the left bank of the cove (fig.11c), not from the Scar's floor as painted. This drawing attests (as does Cat.no.9) to the artist's determination to explore the site from many angles in order to grasp the essence, the soul as it were, of the scene, for the ascent is arduous and Ward had already fixed on a composition which made this view irrelevant. From this vantage point, as he has shown, a large outcropping on the right obstructs the falls.

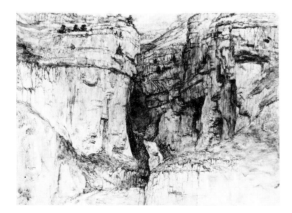 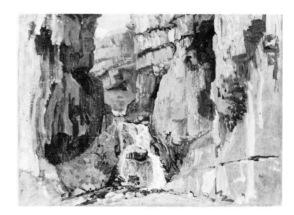

fig.12 James Ward, 'Sketch for Gordale Scar', [Panoramic view] *Tate Gallery* [Cat.no.5]

fig.13 James Ward, 'Study for Gordale Scar', [View of the Falls] *Tate Gallery* [Cat.no.12]

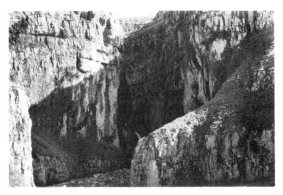

[c]

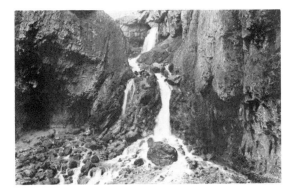

[d]

Ward's close-up drawing of the cataract (fig.8) is also factually accurate; it demonstrates that the falls and the surrounding rock formations could not be experienced in their totality at close range in a horizontal composition although an attempt to do this occurs in fig.13. Other artists, when portraying the site, tended to concentrate on the cataract alone (figs 1–4), and usually resorted to a vertical format to depict the upward thrust of the cliffs projecting out above the falls. These views also contain human forms, which establish scale and psychologically involve the viewer of the image with the scene portrayed.[18] As a visitor outside the picture plane, the viewer identifies with the figures depicted and shares, through association, their emotional response.

In Ward's painting, there are no human forms within the picture itself; however, the human presence is implicit in the glance of the bull, which stares at the viewer of the painting, making us feel like an intruder in his domain. The countless animals emphasize the primordial nature of the painted scene since the creatures portrayed were not there when Ward visited the site. The wild goat, mentioned by Gray, had by Whitaker's time been 'banished from the side of Gordale,'[19] and neither the red deer nor the cattle, representatives of Lord Ribbledale's famous herd, roamed freely, rather they were maintained in the park at Gisburn. Because of their number, the animals also present an exaggerated sense of the Scar's scale, for only in the field in front of the cove – hundreds of yards from the falls – could such an array of beasts be assembled. As for the herd of deer emerging from a cave-like formation (neither present nor possible in the narrow gorge that houses the cataract) and strung out along the imaginary left bank of the stream, Ward has greatly distorted reality to create an effect of enormous space. But it is precisely this unrealistic, expanded space that makes 'Gordale Scar' such a powerful image and conveys to the viewer the true grandeur of the real site.

A reconstruction of how Ward gradually achieved pictorially that sense of

immense depth and breadth experienced as one actually moves through the cove toward the Scar can be made from the series of drawings, oil studies and paintings. From the earliest overall drawing and the 'first sketch' (figs 9, 10) it is evident that Ward wanted to convey an impression of the Scar in its totality even though such a portrayal would not accord with what actually could be seen at any given moment or from any one point. In the drawing dated 15 August (fig.9), he established a perspective scheme and defined planes while in the 'first sketch' (fig.10) he blocked out the Scar into areas of black and white, suggesting essential elements such as the falls, shape of the foreground, indentations in the cliffs, and the white bull. However, a shadowy outline of a bull and suggestions of cattle are evident in the earlier sketch. On the 16 and 19 August, he returned to record certain details (Cat.nos 4, 5, 8, 9), having in the interim visited other spots in the area, including the lead mines near Malham. The trips to the lead mines and probably to Malham Cove, while not directly related to the painting, undoubtedly had their impact on Ward and may well have affected the final visualization of the scene. The limestone walls in the painting, for example, take on the appearance in certain passages of the stalactites and stalagmites that Ward saw in the mines, imparting to the geological formation an eerie quality; and the amphitheatre-like space of the composition is closer in feeling to Malham Cove than to the area in front of Gordale Scar.

With these initial impressions before him (there are undoubtedly others still to be discovered[20]), Ward must have then worked up the small oil study, of the overall composition, now at Yale (fig.14). That Ward intended from the very beginning to portray the scene from a great distance is apparent from the narrowness of the falls and the black mass immediately below, a vestige no doubt of the projecting formation found in the panoramic oil wash drawing and 'first sketch', which was eventually transformed into a pile of rocks. The Yale study follows the 'first sketch' very closely with the exception that the falls have been shifted to dead centre, necessitating an increase of the left-hand cliff. Moreover, the bull, although he retains his diminutive size, has been brought closer to the picture plane. This work probably dates from mid-August 1811, when the artist was still at Gisburn Park. It (and perhaps also the study at Leeds, fig.15) was undoubtedly shown to Lord Ribblesdale to disprove Sir George Beaumont's contention and would have served as the basis for the commission.

In the Leeds version, the Scar appears to be nearer. The right and left-hand sides of the composition have been brought in. More importantly, the simplification and enlargement of the rock formations by the use of pronounced perspective lines on the right cliff as well as the more dramatic handling of light and shade help to create a telescopic effect. With a bigger bull placed on a knoll and the cattle made smaller in the middle distance, the pictorial space on the floor of the cove has been greatly increased at the

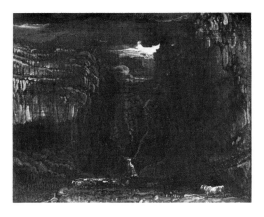

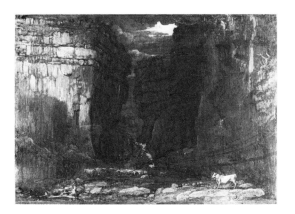

fig.14 James Ward, 'Oil study for Gordale Scar', *Paul Mellon Collection*, Yale Center for British Art [Cat.no.32]

fig.15 James Ward, 'Oil study for Gordale Scar', *Leeds City Art Galleries* [Cat.no.33]

same time as the lighter, simplified cliffs loom larger. Visually, the lighting and monolithic treatment of the cliffs, which push against the top of the picture plane, begin to give the composition a vertical orientation despite the horizontal shape of the canvas.

The large finished study at Bradford (fig.16), dated 1813 and exhibited at the British Institution early in 1814, contains significant changes only some of which can be attributed to the increased size of the canvas. Here, Ward has virtually eliminated the foreground, bringing the bull almost flush with

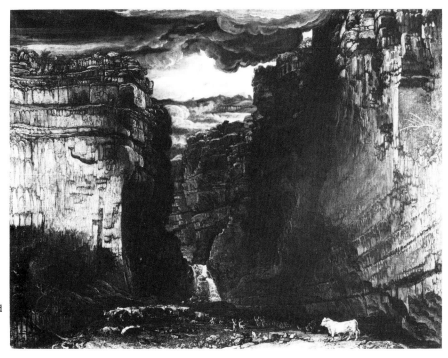

fig.16 James Ward 'Finished study for Gordale Scar' *Bradford Art Galleries and Museums* [Cat.no.34]

the picture plane (its position in the final work). By decreasing the animal's size in relation to the striations on the right-hand cliff, he emphasized even more the height and width of the Scar. Although in the Yale and Leeds versions, Ward had suggested the cattle in the left centre, he has in the Bradford study increased their number and, thus, pictorial depth. In addition, the herd of deer, introduced right centre, visually requires a greater space to hold them than was present in the two smaller oil studies. Moreover, the trickle of a waterfall has now become a broad torrent. Based on his close-up of the falls, the cataract, its size greatly exaggerated, assumes a commanding and dramatic position in the composition. By magnifying this element out of all proportion to what could be seen at the distance portrayed, Ward lessened the apparent depth depicted in the earlier versions; however, he has compensated for this by placing more animals in the middle distance. The reintroduction of a stormy sky, almost eliminated from the Leeds study, helps define the scale of the scene at the same time as it corrects the compositional awkwardness of the cliffs reaching to the top of the painting and adds to the foreboding mood of the work. As would be expected in a more finished painting, Ward has devoted considerable attention to details such as landscape elements and rock formations.

The final picture at the Tate (fig.5) corresponds closely to the Bradford example with some significant differences. First of all, the format is now almost square; a third of the cliff has been eliminated from the right-hand side and a small portion of the left as well. The change in format may well have been necessitated by the expected placement of the picture at Gisburn Park,[21] but squaring the picture also tended to tighten the composition at the same time as it emphasized the height of the cavern walls. This change focused even greater attention on the falls and created a more effective realization of depth, reinforced by the introduction of the cave and herd of deer in the left distance. Ward also increased the threatening aspect of the overhanging rocks, mentioned by the various writers on the Scar, by undercutting them and by turning rounded forms in the Bradford picture into sharp angles and points. In addition, the cooler and more restricted palette infuses the scene with a new sombreness.

The number and type of animals portrayed in the final picture can only be partially ascribed to compositional considerations. The fighting bucks fix the season as summer, the time of year Ward visited the site, but they also underscore the primeval power sounded by the white bull, the raging cataract, the stormy sky. According to Bewick, stags, virtually unknown in a wild state in cultivated parts of Britain, were kept in parks and were on the verge of extinction.[22] Nor did cattle roam freely near the Scar. Lord Ribblesdale's herd of the wild aboriginal cattle of Lancashire, which were maintained at Gisburn, were also dying out.[23] Even the goat, strangely solitary in Ward's painting, had disappeared from the area. In fact, the only

animals to be seen in the vicinity were sheep, and they are noticeably missing from Ward's painting. By filling his canvas with these particular animals, the artist portrayed the Scar not as he found it but as it may have been in the distant past. He reinforced this conception of the prehistorical nature of the site by excluding the upper passage of the stream made about 1730, so prominent a feature in other views.

The white bull, while it unquestionably alludes to the wild cattle owned by Lord Ribblesdale, might have yet another meaning. Powerful and suspicious, it lords over a geological amphitheatre that, in a way, mirrors the world. Ever since the early eighteenth century, the bull had symbolized England.[24] With the country then engaged in a life-and-death struggle with Napoleon, this representative of the original race that once flourished in Britain's forest may have embodied for Ward the natural strength of the country. Wary, the bull looks out at the viewer, threatening at any moment to defend his family and domain from the intruder.[25]

The profusion of wild animals together with the expanded space, the thundering cataract, and the storm-ripped sky capture the sublimity of Gordale Scar. The sublime along with the beautiful and the picturesque were terms commonly applied to visual experiences in Ward's day. Efforts to isolate the distinctive qualities of these three categories dominated British aesthetic thought in the eighteenth and early nineteenth centuries.[26] Theories of the sublime, originating with the publication in England of a treatise by the first-century Greek author Longinus, were at first applied to rhetoric and then literature.[27] However, the concept gradually came to be used in reference to the visual arts and nature as well. By the time Edmund Burke published his influential *A Philosophical Enquiry into the Origin of our Ideas of the Sublime and Beautiful* in 1757,[28] the distinction between the beautiful and the sublime was well established. Burke maintained that certain innate qualities of an object such as smallness, smoothness, variation, delicacy, fair colour were essential to beauty. For the sublime, obscurity, vastness, infinity, power – things capable of eliciting terror in the viewer – were among the factors he identified.

The picturesque, as popularized at the end of the eighteenth century by the Reverend William Gilpin in his numerous travel accounts, was a term used simply to differentiate objects or views suitable for pictorial representation from those that were not. An attempt to establish it as a separate category distinct from the beautiful or the sublime was made by Sir Uvedale Price in 1794;[29] however, the picturesque remained a more ambiguous term because it frequently blended with either aesthetic extreme. The two great characteristics of the picturesque, according to Price, were variety and intricacy, and he identified strong contrasts in form, colour, and light and shadow, as well as such qualities as roughness, sudden variation and irregularity with the category.[30]

Although artists produced works of art that fall broadly into one of these three categories and were unquestionably, either consciously or unconsciously, influenced by the prevalent aesthetic concepts, it is unlikely that selection of subject or manner of execution was dictated solely by such ideas. And, in fact, works frequently contain elements associated with two of the categories. These theories, devised by connoisseurs and literati, were probably more important to the amateur or educated viewer in helping him appreciate what he was seeing than to the professional artist. Nevertheless, such terms can, on occasion and with cause, be applied to specific works. In this case, they will be especially useful in clarifying why 'Gordale Scar' is, indeed, an essay in the sublime.

Produced within a few years of each other, 'Cattle-piece' (fig.17), 'Tabley Lake and Tower' (fig.18) and 'Gordale Scar' (fig.5) are variations on the same theme. Each depicts a summer landscape populated with cattle, including a bull, and yet each is strikingly different in its handling of these similar elements. On the basis of Ward's own comments, contemporary remarks, or visual evidence, each work seems to epitomize one of the three major aesthetic categories.

With its strong contrasts in light and shadow, rich colouration and rustic setting, 'Cattle-piece' clearly qualifies as a picturesque scene according to Price's criteria. Although the painting was once called 'Regent's Park' and the locale has been tentatively identified as Marylebone Park (primarily because Regent's Park was created from Marylebone after the date of this painting), the actual site is by no means certain and is fundamentally irrelevant to the impact of the painting. The dramatic handling of light and colour indicates that Ward was not concerned with location *per se*. In fact, it is more likely that the composition is a creation of the artist's imagination designed simply to please the senses, rather than a topographical rendering of a specific place.

The rustic figures, whose dress identifies the season as summer, add to the picturesque scene defined by the farm building, ramshackle ramp and cattle. The brilliant band of orange yellow in the sky establishes evening as the time of day while the dispersing dark clouds and wet ground reveal it has just rained. Strung out in playful irregular silhouettes against the light and massed in groups in the field, the cattle turn this richly coloured picture into a delightful rural scene. Even the bull, who seems to glow with some inner light, contributes to the pervasive air of quietude. Presenting no threat, he simply acknowledges the viewer with a glance, his head bowed in a submissive arc. The apparent mild nature of this animal is far removed from the pent-up power exhibited by the wild bull in 'Gordale Scar'.

If 'Cattle-piece' in its picturesque use of *chiaroscuro* alludes to Rembrandt, 'Tabley Lake' and 'Gordale Scar' make more than a passing reference to Claude Lorrain and Salvator Rosa respectively.[31] By turning to these artists,

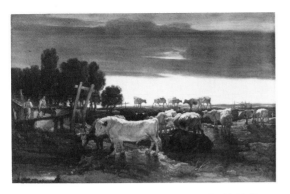

fig.17 James Ward, 'Cattle-piece ?Marylebone Park', [A Cow-Layer: Evening after Rain] *Tate Gallery* [Cat.no.36]

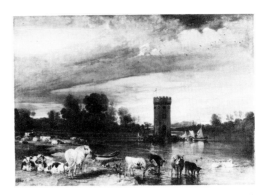

fig.18 James Ward, 'Tabley Lake and Tower' *Tate Gallery* [Cat.no.37]

considered at the time the masters of the beautiful and the terrible sublime, Ward declared his artistic intentions. However, the paintings themselves, with their opposite visual effects, provide the clearest evidence of their particular aesthetic statements and can serve almost as text-book examples of Burke's definitions:

> The sublime objects are vast in their dimensions, beautiful ones comparatively small; beauty should shun the right line, yet deviate from it insensibly; the great in many cases loves the right line, and when it deviates, it often makes a strong deviation; beauty should not be obscure; the great ought to be dark and gloomy; beauty should be light and delicate; the great ought to be solid and even massive.[32]

That Ward had the beautiful in mind when he conceived 'Tabley Lake' is borne out by a letter to his patron, Sir John Leicester, in which he defends the composition:

> I have had to tell a story that has been told before so beautifully as to make me tremble – yet I must consider them as told with great Poetic liberties as to the Picturesque I see Tabley Tower as anything but a Picturesque or Rustic object. Accordingly I reasoned thus, The Tower is the subject – its forms are classically simple and elegant, how am I to unite this with a group of Cattle of all colours and breeds, without doing violence to everything like appropriate composition. Nothing vulgar can be admitted – if I take liberties that others have done, I am only repeating the ground that has been already three times passed over, the only road left to me is to produce something new by a more rigid attention to truth. The effect is such as I have seen on the spot. It is a close sultry day, what is vulgarly called a Muggy or a murky day – when the air is charged with Electric fluid – preparatory to a Thunder-

storm. A gentle breeze is slowly running [?] over the surface of the Lake which gives it the colour by a very imperceptible ripple, which increases on the near side, by which I am enabled to preserve the comparative still and elegant forms of the Boats etc near the Building and a more picturesque form in the Boat near the foreground with the cattle, chaining [?] them together by imperceptible degrees – thus one extreme glides into the other without violence. The Foliage near the Tower you call stiff and formal, I would term classically simple uniting with – the Tower running on but increasing in variety as it approaches the Shepherd, etc – to the distant Cattle, and led on by the sail etc to the climax of light colour and interest in the foreground group the focus of which is the Young White Bull the Adonis of my picture (the bold foreshortening of which may not be universally understood but which I know to be right) his beauty and vivacity add by contrast to the Repose around and is carried – by the Boat to the speckled Cow whose colours are made to harmonise with it and lead to the more strong coloured Cow and Calf which gives air to the whole – and the swallows independent of the sentiments add as another link to the chain – leading to the swans whose classic form and hue act as a contrast to and yet assimilate with the tower etc etc.[33]

Ward claimed he was striving for an effect quite different from those achieved in paintings of the same scene by other artists. Presumably, he had in mind J. M. W. Turner's two views of the lake and tower, and perhaps either that of Richard Wilson or Henry Thomson.[34] He argued that the forms of Tabley Tower are classically simple and elegant, qualities of beautiful not picturesque objects; and he could have cited Claude's use of similar towers to substantiate further his position. Turner had juxtaposed the tower with the Palladian-style house, supposedly to underscore the structure's picturesqueness. Since Ward did not consider the tower picturesque, he painted it from the house side of the lake so that no comparison was possible. There can be little question about the picturesque effect of Turner's 'Tabley: Windy Day' with a strong wind churning up the water and filling the sails of the boats.[35] For his companion picture, Turner took the same view as seen in the calm of morning.

Unlike Turner, Ward did not highlight the tower's uniqueness by isolating it in the lake but visually set it in a Claudian landscape stirred by a gentle breeze. The viewer is carried slowly back into space (in keeping with Burke's precepts) through a series of diagonals and overlapping planes: the eye does not jump abruptly from foreground to tower to background as in Turner's works. The composition is enclosed; the picture does not present a sublimely infinite panorama as, for example, 'Bulls Fighting'. The time of year is summer, suitable to the introduction of an *Adonis* in the form of a bull.[36] Ward's mythological allusion reinforces associations with the

classical landscapes of Claude, exemplar of the beautiful in painting. Moreover, the colours, while appropriate to the time of year, are muted and not the rich picturesque tones of 'Cattle-piece' or the sublimely sombre hues of 'Gordale Scar'.[37]

'Tabley Lake' exudes an air of calm and repose: the wind barely stirs the pennant atop the tower and merely ripples the surface of the lake. The placid cattle rest or graze peacefully; the bull does not guard his domain against intruders as in 'Gordale Scar' but rather leads the viewer into the picture. To emphasize the serene majesty of the scene, Ward has introduced the swan whose 'classic form' was judged the most beautiful found in birds.[38] Ward in his letter to Sir John did not label 'Tabley Lake and Tower' an exercise in the 'beautiful' as defined by Burke, but it is obvious that it was so intended. The classical references, choice of colours, concern for elegant forms, feeling of repose, and gentle recession in the composition as well as the contrasts Ward drew between his work and the other views demonstrate that beauty was the dominant aesthetic expression he wanted to achieve.

Ward's intention in regard to 'Gordale Scar' becomes all the more clear when it is compared with 'Tabley Lake', painted at the same time.[39] To understand the beautiful versus the sublime as visualized by Ward, enumeration of basic differences between these two works will prove helpful. First, the pictures vary significantly in size – 'Gordale Scar' is extremely large (131 × 166 inches); 'Tabley Lake', comparatively small (37 × 53½ inches). Although the size of each painting was undoubtedly determined to a large extent by the patron, the difference in format must have affected Ward's conception, for smallness was a characteristic of beauty while vastness, one of the sublime.[40] In 'Gordale Scar' areas of darkness are juxtaposed against those of intense light in contrast to the uniform lighting of 'Tabley Lake'. In the former, the eye shoots back rapidly through dark, overhanging cavernous walls to the brilliantly lighted torrent cascading over the rocks and up the seemingly endless chasm beyond; there is no gentle recession into pictorial space. Although the canvas of 'Gordale Scar' is almost square, the orientation of the picture is pronouncedly vertical. This creates a dynamic effect exactly opposite to the restfulness achieved in the horizontal composition of 'Tabley Lake'. The abrupt deviation from the vertical near the top, where the cliffs converge toward the centre and large rock formations project over the cavern below, adds a dramatically threatening note. Overhead, dark ominous clouds portend a violent storm, an atmospheric condition quite different from the sultry summer sky of 'Tabley Lake' or the cool, damp evening of 'Cattle-piece'. The colours of 'Gordale Scar' are sombre; those of 'Tabley Lake', delicate.

Ward's desire to convey a sense of that sublime horror with which Gordale Scar was viewed at the time is repeatedly manifested in his overall treat-

ment and in his handling of details. The profusion of wild animals, not actually present in Ward's day, both exaggerate the vastness of the site and symbolize its savagery. The fighting stags underscore the violent power implied in the menacing white bull whose defiant attitude is psychologically opposite from that presented by a similar animal in 'Tabley Lake' and 'Cattle-piece'.[41] The limited palette produced an effect suitably dark for Burkean sublimity; and Ward further dramatized the fall by *chiaroscuro*, throwing into 'obscurity' much of the middle distance.[42] By simplifying the geological formation of the cavern walls until they rival Stonehenge in their monolithic quality, he has emphasized their massiveness and exaggerated their scale.

Through the manipulation of form and colour, Ward did more than simply distort the topography of the site for the sake of a sublime effect. He also captured the Scar's strange supernatural power which all visitors then consciously relished and today subliminally experience. Whitaker, in his evocative description of Gordale, wrote ecstatically of the cove's 'ponderous and marble jaws.' This Miltonic image verbally expresses the visual effect Ward achieved by bracketing the dark central orifice with two towering, brilliantly lighted masses of rocks. The Scar's yawning 'mouth,' as painted by Ward, calls to mind Flaxman's illustration of a devouring 'Dis' in Dante's *Inferno* (1793). And the vaulting forms that carry the viewer upward to a clearing in a foreboding sky pictorially convey the cathedral-like quality of the overhanging rocks noted by Whitaker. Such an association was not only consonant with theories of the sublime but also reflected the artist's own deeply religious sentiments.

'Gordale Scar', then, unlike 'Tabley Lake', does not possess what Ward called a 'rigid attention to truth.' It is a creation of his poetic imagination, an attempt to capture the essence of the Scar, its sublimity and grandeur, as described by Gray, Whitaker, Dayes, and others. The gargantuan proportions of the canvas gave the artist licence to explore the subject on an heroic scale. While the symbolic meaning of the painting is open to question, its pictorial and psychological effects are quite clear. Ward has synthesized a series of visual impressions gained as one walks across the stony and desolate valley, ringed by immense limestone formations, toward the falls and overhanging rocks. It is not one moment in space and time that he portrayed but the totality of the experience. To communicate this sensation to the viewer, he eliminated obstructions and exaggerated the height, breadth and depth of the Scar. Rock formations have been simplified to emphasize mass and monumentality. Overhangs, undercut to hint at their possible imminent collapse, inject a note of painful suspense. *Chiaroscuro* and a sombre palette create an ominous atmosphere. The vast array of wild animals underscores the landscape's primordial nature; the menacing bull and fighting stags epitomize raw, untamed animal power.

Visually, the viewer of the painting experiences a vertiginous burst of elation in the rush from the light low foreground up the dark cavern walls to the high cliffs. Compositionally, he is led from the threat of the bull, to the savage encounter between the bucks, to the awesome turbulence of the falls and the foreboding sky above. Mentally, he proceeds from fear elicited by confrontation with the brute force of the animals to fear of nature and of God evoked by the raging torrent, vaulting Scar and stormy heavens. Representations of frightening noise abound: one can almost hear the wilderness in the clash of the stags, the roar of the waterfall, the whistling wind that rips the sky. Such physiological stimuli and psychological responses were clearly calculated to arouse the terror then considered integral to the sublime. But 'Gordale Scar' is not simply a translation of this aesthetic onto canvas. Displaying in its dramatic handling of light and form the intensity of feeling characteristic of Ward's most powerful works, it transcends the concept of the sublime by achieving sublimity as a work of art.

Edward J. Nygren

1 Thomas Gray, 'Journal in the Lakes,' *Works* (London, 1884), I, 277.

2 *Idem.*

3 According to Gray, two prints of Gordale had been made by Smith and Bellers (p.278); I have been unable to locate copies. Gray also mentioned a visit to the area by Francis Vivares, who executed a view of Malham Cove in 1753; I do not know of his having portrayed Gordale Scar.

4 These include: John Housman, *A Descriptive Tour and Guide to the Lakes . . . and a Part of the West Riding of Yorkshire* (Carlisle, 1800); Edward Dayes, 'An Excursion through the Principal Parts of Derbyshire and Yorkshire,' *Works* (London, 1805); and Thomas Whitaker, *The History and Antiquities of Craven* (1805; London, 1812). All three works went through two or more editions within a decade of publication. Perhaps the most famous writer to effuse over Gordale was William Wordsworth whose short poem of 1819 was inspired by William Westall's view (fig.3).

5 Dayes, pp.62–4. Dayes took the trip in 1803, but his remarks were published after his death the following year. The hole was reportedly made about 1730 as the result of a thunderstorm. Prominent in most contemporary views (see figs 1–4), it does not appear in Ward's painting.

6 This story has been repeated in most discussions of Ward's painting. The basis of the report may well have been Ward's own remarks; see the letter from James Ward to his son, George, 22 January 1857, in Appendix III.

7 Whitaker, p.208.

8 See, for example, Sir George Beaumont's letter to William Gilpin in Gilpin's *Five Essays on Picturesque Subjects* (London, 1808), pp.165–6; but this view was generally accepted at the time.

9 For biographical material on Ward, see: C. Reginald Grundy, *James Ward, R.A.* (London, 1909); G.E. Fussell, *James Ward, R.A.* (London, 1974), and Edward J. Nygren, 'The Art of James Ward, R.A.,' Ph.D. Dissertation, Yale University, 1976. Ward's *Waterloo Allegory*, a study for which is at the Royal Hospital, Chelsea, was a professional disappointment of major proportions. He began this painting shortly after completion of 'Gordale Scar'. For contemporary reactions to 'Gordale Scar', see Chronology and Appendices I–III.

10 Fussell, pp.72–8, 82–115, provides the fullest treatment of this project, but it is also discussed in Grundy (pp.xxx–xxxi) and Nygren (pp.12–15).

11 The Honourable Thomas Lister, Lord Ribblesdale's son, referred to Ward in these terms (see Chronology, June 1811), but he was merely mouthing the opinion of others.

12 See Cat.no.36.

13 See Chronology, 9 March 1811. It seems likely that Ward set a high figure on his instruction in part to discourage Lister.

14 Fussell, p.102. Such a painting is not however recorded in the manuscript catalogues of the art at Gisburn Park, Bradford-Lawrence Collection (MD 335), Yorkshire Archaeological Society (Leeds).

15 See Chronology; Fussell, pp.101–2, charts Ward's general movements that summer.

16 Ward also made a graphite drawing of the river Ribble, inscribed 'Gisburn Park' (Prudence Summerhayes Collection). The exact date of the drawing is not known. The cattle, not indigenous to Gisburn, were thought to have been brought there in the time of Henry VIII from Whalley Abbey in Lancashire.

17 1810 and 1811 saw very wet summers in England generally; see: J.M. Stratton and Jack Houghton Brown, *Agricultural Record in Britain A.D.* 220–1977 (London, 1978).

18 Exceptions to this are Girtin's view (fig.6) and a watercolour by J.M.W. Turner (Turner Bequest CLIV-O). Turner's large watercolour sketch, done about 1816, takes liberties with the site similar to Ward's. There are later treatments of the Scar; but these are irrelevant to this study. They do not attempt to rival Ward's canvas in size or conception.

19 Whitaker, p.207.

20 In Ward's 'Account Book' (MS, Mme E. Arnold Collection, Geneva), he recorded selling an unspecified number of 'Drawings for Lord Ribblesdale's Picture' to John Buonoratti Papworth, the architect, on 4 August 1815, for £21. None of the works exhibited here can be identified with that group, which may have included oil studies and sketches of cattle.

21 Lord Ribblesdale supposedly planned to build a new house or make an addition to the old one, but never did, probably because of his financial problems in 1812 and 1813. See Ward's letter to his son (22 January 1857) quoted in Appendix III; also see: Grundy, p.xxxvi; and Fussell, p.106.

22 Thomas Bewick, *A General History of Quadrupeds* (Newcastle Upon Tyne, 1790), pp.109–10.

23 *Ibid.*, p.34. The breed became extinct in 1859.

24 With the publication of John Arbuthnot's *The History of John Bull* (1712) the bull became a symbol for the English public.

[25] Ward's symbolic use of animals in paintings before and after 'Gordale Scar' increases the likelihood that the creatures here depicted are more than formal elements in a composition. The theme of a bull protecting his family is frequently encountered in the artist's works, most notably in a large canvas called 'Group of Cattle' or 'Protection' (also 'Bull, Cow and Calf') of 1822 (Tate Gallery).

[26] The literature on this subject is vast; however, the basic works include: Christopher Hussey, *The Picturesque* (1927, rpt. Hamden, 1967); Samuel H. Monk, *The Sublime* (1935; rpt. Ann Arbor, 1960); and Walter John Hipple, Jr. *The Beautiful, The Sublime, and The Picturesque in Eighteenth-Century British Aesthetic Theory* (Carbondale, Ill., 1957). J. T. Boulton's edition of Edmund Burke's *A Philosophical Enquiry into the Origin of Our Ideas of the Sublime and Beautiful* (1958; rpt. Notre Dame and London, 1968) has a valuable introduction on that seminal work. Edward Malins, *English Landscaping and Literature 1660-1840* (London, 1966) provides some fresh insights into the relationship of these aesthetic concepts, particularly the 'Picturesque,' with literature and gardening. Among more recent works are: Gerald Finley, 'The Genesis of Turner's "Landscape Sublime"' *Zeitschrift für Kunst-Geschichte*, 42 (1979) in which Finley makes some interesting observations about 'Gordale Scar'; Andrew Wilton, *Turner and the Sublime* (London, 1980) which offers an excellent coverage of the sublime in general as well as a rich analysis of its importance to Turner; and Peter Bicknell, *Beauty, Horror, and Immensity* (Cambridge, 1981).

[27] Monk reviews the history and growth of Longinus's reputation and influence in England (pp.18-28) from its first English translation in 1652 (it was published in Latin at Oxford in 1636); but it was not until the early eighteenth century that an English translation of the work, taken from Boileau's translation in French (1674) became widely available.

[28] A new edition appeared every three years for thirty years; see: Boulton, p.xxii.

[29] *Essay on the Picturesque compared with the Sublime and Beautiful* (London, 1794). Price's approach, derived from Burke, was strongly criticized by Richard Payne Knight, *Principles of Taste* (London, 1805); for this controversy and Price's and Knight's contribution to the literature, see: Hipple, pp.202-23, 247-77.

[30] Price, pp.76, 87, 105, 112; Price also identifies a host of objects as picturesque.

[31] Elizabeth Wheeler Manwaring in her important study, *Italian Landscape in Eighteenth Century England* (1925; rpt. New York, 1965), examines the influence of Claude Lorrain and Salvator Rosa on English taste; see especially Chapter III (pp.35-56).

[32] Burke, p.124.

[33] Letter from James Ward to Sir John Leicester, 7 January 1814, quoted in: Douglas Hall, 'The Tabley House Papers,' *The Walpole Society*, 38 (1960-1962), 95-96. I wish to thank the Walpole Society for giving me permission to quote this letter at length.

[34] Turner's 'Tabley: Windy Day' (1808) and the Thomson are at the Victoria University of Manchester, Tabley Collection, the bequest of Lt. Col. J. L. B. Leicester-Warren; the other Turner, 'Tabley: Calm Morning' (1808), is at Petworth House (Lord Egremont Collection). The Wilson is in the collection of Lord Ashton of Hyde.

[35] See Price, p.54, on the picturesque quality of rough water.

[36] According to John Bell, *New Pantheon* (London, 1790), I, 13, Adonis signified the sun 'who during the summer is with Venus.'

[37] Burke, pp.81-2, listed those colours most suitable for sublime effects – black, brown, deep purple, and so forth; for beauty, 'clean and fair' colours not 'the strongest kind' were preferred (pp.116-17).

[38] Burke, p.95. The swan may have been introduced because it is associated with Venus, Adonis's lover.

[39] Although Ward made changes in the painting to please his patron (see Cat.no.37), the basic composition probably remained the same.

[40] Burke, p.124. It should be noted that vastness was generally recognized as a sublime quality; for example, Dayes (p.272) and Knight (p.362) both comment on it. Boulton in his introduction to Burke (pp.cxi-cxiii) discussed at length James Barry's emphasis on the size of the canvas as an important element in creating a sublime artistic effect and Burke's role in establishing this attitude. 'Gordale Scar' was chosen by Boulton as an extreme example of this practice (p.cxiii).

[41] Although the bull, because of its power, was considered a sublime animal by Burke (p.65), the treatment of the animal clearly affected how it was perceived by the viewer.

[42] Burke, pp.81-2; pp.79-80. The section on 'light' deals with the great effects produced by quick transition from light to darkness.

1810

Spring Exhibits seven paintings at the Royal Academy.

6 May First reference to Ward in a letter from the Honourable Thomas Lister to his father, Lord Ribblesdale[1]: 'Ward's Picture of the horse Eagle[2] is beyond all conception & raises my awful veneration for that artist beyond all bound'

14 May Second reference to Ward in a letter from Lister to Lord Ribblesdale[3]: 'I had a few moments conversation with Ward to-day & am to call again tomorrow – he is carrying his art beyond all imitation or description.'

1811

11 February Elected Academician of the Royal Academy along with David Wilkie, Richard Westmacott, Robert Smirke, Jr, and Henry Bone.

9 March Joseph Farington records in his diary a conversation with Thomas Lawrence about Lister's attempt to gain access to Ward's studio on a regular basis and to receive instruction from the artist. Ward reputedly asked 500 guineas for two-months' instruction; Lister felt Ward had acted improperly by mentioning such a sum.[4]

Spring Exhibits eight paintings at the Royal Academy.

June Undated letter from Lister to Lord Ribblesdale discusses the Academy Exhibition[5]: 'Turner not inferior to Claude – Ward allowed to beat Paul Potter out and out.'

20 June Farington records: 'Ward showed me a picture today which He intended to offer to the Royal Academy as his *Probationary Picture*; the Subject two naked Bacchanalian children; a performance much inferior in merit to His pictures of Horses. He said He chose to send this picture, because he did not like to be admitted into the Academy as a Horse Painter.'[6]

27 June Leaves London for Poole in Dorset. Visits Brownsea, Wilton, Malvern Hills, Tewkesbury on his way to Tabley Park, home of his patron, Sir John Leicester.[7]

20-24 July Sketches cattle at Tabley (Cat.no.21). Some groups subsequently incorporated in 'Gordale Scar'.

27 July Leaves Tabley Park. Visits Manchester, Blackburn and Whalley Abbey on his way to Gisburn Park, the estate of Lord Ribblesdale, in Yorkshire.

6 August Arrives at Gisburn Park.

14 August First dated drawing of the Scar (Cat.no.1).

15 August First overall composition created (Cat.no.2).

16 August Returns to sketch the Scar (Cat.no.4).

17 August Sketches the lead mine, near Malham Water (Cat.nos 6 and 7).

19 August Additional on-the-spot sketches made of the Scar (Cat.nos 8 and 9). Letter from T. Gwennup, art dealer in New Bond Street, to Lord Ribblesdale[8]: 'It must be delightful to your Lordship as well as to Mr. Lister, the hav[g] Mr. Ward at this time of Year with you surrounded by many fine Prospects & scenes so well adapted to his Pencil – I have no doubt but Mr. L. will derive much advantage by his studies.'

22–23 August Sketches cattle at Gisburn Park (see Cat.nos 13-19).

30 August Leaves Gisburn Park. Returns to Tabley Park on way back to London. Ward's 'Account Book' contains an entry for Lord Ribblesdale (see fig.7).[9] Although the entry is ambiguous on the actual date of the commission, first payment appears to have occurred in April of the year following Ward's only recorded visit to Gisburn Park and Gordale Scar.

11–20 September At Wychnor, the estate of his patron, Theophilus Levett, in Staffordshire, where he makes studies of deer, some of which may have been those incorporated in 'Gordale Scar'.

15 October Again at Wychnor.

November Near Tutbury, Staffordshire, visiting Rev. John Ward of Micklehover (no relation).

1812

30 January Farington records in his diary: 'Ward called on me today. He spoke of the state of his health being so alarming as to cause Him as He said "to make up his mind to it" meaning that His disorder would prove fatal. He described the sensations He felt, and was apprehensive that an Ulcer or Tumour was forming in the great vessel which leads from the throat to the stomach'[10]

13 February Farington: 'Lawrence called and spoke of Ward who He had been informed by the Honourable Mr. Lister, son of Lord Ribblesdale, is in a dangerous state of health. I told Him what Ward had mentioned to me respecting it.'[11]

8 April Records in 'Account Book' receipt of £100 from Lord Ribblesdale on account for 'Gordale Scar' (see fig.7).[12]

28 April Prevented by illness from attending the General Meeting of the Royal Academy to receive his diploma, which he finally gets at the November meeting.

Spring Exhibits seven paintings at the Royal Academy.

15 May Letter from Lister, misdated 1811, to Lord Ribblesdale:[13] 'Ward's Portraits of Horses are beautiful Ward won't let me see Gordale'

31 October Visits Farington and discusses a variety of subjects, including his improved health.[14]

2 November Receives his diploma at the General Meeting of the Royal Academy.

10 December Annual General Meeting of the Royal Academy. Ward appointed to the Council along with Smirke, Westmacott and Wilkie.

1813

10 January Records in 'Account Book' receipt of £93–13 by a Rippon Bank Bill; also records two £50 drafts on banks dated 23 November and 30 November 1813 [sic] (see fig.7). The entry is confusing but the dates of the last two drafts were probably inaccurately recorded and should have been 1812.[15]

29 January Speaks with Farington about the forthcoming elections at the Royal Academy.[16]

13 February Farington records the proposal at a meeting of the Council to form a club of Academicians, who would dine together six times each year.[17] Although Ward becomes a member, he resigns four years later.

3 March Attends first meeting of club.

Spring Serves on Hanging Committee with Wilkie and Westmacott for the annual exhibition of the Royal Academy. Ward exhibits eight paintings, mostly animal portraits.

7 April Farington records: 'Ward complained to Smirke of Wilkie's conduct in arranging pictures'[18] Wilkie, on the other hand, wrote ecstatically about the experience.[19]

27 April Farington records dinner at the Academy with Howard, Smirke, Ward, Westmacott and Wilkie: 'Ward read the Proof sheets of His account of Mary Thomas, the fasting Welsh woman, and of Ann Moore of Tutbury.'[20]

May *Sporting Magazine* gives Ward a rave review.[21]

13 May Letter from Lister to Lord Ribblesdale, discussing his artistic progress:[22] 'Bury recommends me to buy one of Ward's horses & copy it but by no means to think of giving way to the idea of going to him –'

20 May Letter from Lister to Lord Ribblesdale[23]: 'Ward has fought off very artfully and I don't see how it will be possible to get from the Bargain; it however prevents your giving him more than the 300.'

22 May Letter from Lister to Lord Ribblesdale[24]: 'I heard Mrs. [?] Ward say a few days ago that the frame & curtain to Gordale would cost 200 gs. – I should think they would be going too far – Bury said he thought Ward had made the most of a bad subject and Lawrence wondered why all the different sort of animals should be collected together –'

4 June Ward records in 'Account Book' selling to Lord Ribblesdale for £1–11–6 a copy of his publication on the two fasting women.[25]

1814

7 January Receipt of £5 from Lister noted in 'Account Book.'[26]

1 February In an article filled with laudatory remarks concerning Ward, *The Monthly Magazine* reports 'Gordale Scar' completed, and indicates the painting will be shown at the Royal Academy that spring; 'Tabley Tower' is also mentioned. This is the first reference to the final picture in the press. (see Appendix I [a])

10 February *The Morning Chronicle* criticizes the finished sketch exhibited at the British Institution along with two other works by Ward. (see Appendix I [b])

March *The New Monthly Magazine* praises the final version of 'Gordale Scar'. (see Appendix I [c])

April *The New Monthly Magazine* favourably reviews the large finished sketch shown at the British Institution. (see Appendix I [d])

Spring Exhibits six paintings at the Royal Academy.

2 May Letter from Lister to Lord Ribblesdale[27]: 'I don't know what to do about Gordale or how to break it to Ward, and I think I should not determine to do anything hastily.'

12 July A bank bill from Lord Ribblesdale for £26, dated 26 May 1814, noted in 'Account Book.'[28]

8 October Letter from Lister to Lord Ribblesdale[29]: 'Ward has done two horses in his high finished manner well – but they are too much laboured by which the general effect is gone'

10 October Letter from Lister to Lord Ribblesdale[30]: 'Tom Lister dined with me yesterday He is also very much struck with Ward's Gordale – '

1815

5 January Noted in 'Account Book' receipt of £2–2 by cash which 'settles for this whole.'[31] The total of £330–15 must have included incidental expenses since £315 is the original figure on the debit side.

1 April Letter from Lister to Lord Ribblesdale[32]: 'Ward means to exhibit that Goliath of a Picture which is one day or other to decorate the walls of Gisburn Park'

Spring Exhibits four paintings at the Royal Academy, including 'A View of Gordale, in the Manor of East Malham in Craven, Yorkshire, the property of Lord Ribblesdale.'[33]

May *The Sporting Magazine* is highly critical of 'Gordale Scar'. (see Appendix I [e])

6 May *The Times* gives a mixed review. (see Appendix I [f])

July *The New Monthly Magazine*, which praised 'Gordale Scar' in March of 1814, is more critical of the painting. (see Appendix I [g])

Mid July 'Gordale Scar' arrives at Gisburn Park.

15 July Letter from the chaplain, Thomas Collins, to Lord Ribblesdale[34]: 'I shall long to open the Gordale case. – May Robinson attempt it? – I will stand over him. – He seems interested in look[g] after both Jobs. Adieu. – '

24 July Letter from Collins to Lord Ribblesdale[35]: 'The Picture Case is just gone thro' the lodge to appearance in a sound condition. I am descending to see it carefully unrolled and stretched in the Frame as ordered. – Robinson promises the greatest Care. – '

25 or 26 July Letter from Collins to Lord Ribblesdale discussing the merits and failings of 'Gordale Scar' and its placement at Gisburn Park. The entire letter is reproduced in Appendix II.

27 July Letter from Lister to Lord Ribblesdale[36]: 'Gordale is put on its stretching frame, & displayed in the hall – where it cannot be seen, & where if put into the Frame it cannot stand – '

2 August Letter from Lister to Lord Ribblesdale:[37] 'Gordale I assure you looks magnificent in the Hall – don't be out of concert with it [illegible Latin phrase] – it has its faults I allow, but so have all things that we do here, & nothing is so bad of all others as a faultless Picture, for it is certain to have no beauties – In my opinion the frame is very detrimental to the performance – it has ten thousand times a better effect without it.'

NOTES

1 The Lister correspondence cited herein is in the Collection of the Yorkshire Archaeological Society (Leeds), Bradfer-Lawrence Collection, MD 335; hereafter referred to as Lister Correspondence Bradfer-Lawrence Collection. I am grateful to the Society for giving me permission to quote extensively from this material.

2 One of the works exhibited by Ward at the Royal Academy in 1810, 'Eagle' is now in the Paul Mellon Collection, Yale Center for British Art, Yale University, New Haven, Connecticut.

3 Lister Correspondence, Bradfer-Lawrence Collection.

4 Joseph Farington, 'Diary', 9 March, 1811, TS, British Museum; hereafter cited as Farington, 'Diary'.

5 Lister Correspondence, Bradfer-Lawrence Collection.

6 Farington, 'Diary', 20 June, 1811. The painting is in the collection of the Royal Academy.

7 For a discussion of Ward's travels in the summer of 1811, see: G. E. Fussell, *James Ward, R.A.* (London, 1974), pp.101–2. Drawings of Brownsea (30 June) and Tytherton (18 and 19 July) are known and further document his travels.

8 Lister Correspondence, Bradfer-Lawrence Collection.

9 James Ward, 'Account Book', (p.59 left), MS, Collection of Mme Eduard Arnold; hereafter cited as: Ward, 'Account Book'. I am grateful to Mme Arnold for giving me permission to reproduce relevant pages from this document.

10 Farington, 'Diary', 30 January 1812.

11 Farington, 'Diary', 13 February 1812.

12 Ward, 'Account Book', (p.59 right).

13 Lister Correspondence, Bradfer-Lawrence Collection. In the letter Lister refers to seeing 'Turner's Picture of Hannibal Crossing the Alps' at the exhibition at the Royal Academy. The painting was shown in 1812.

14 Farington, 'Diary', 31 October 1812.

15 Ward, 'Account Book', (p.59 right).

16 Farington, 'Diary', 29 January 1813.

[17] Farington, 'Diary', 13 February 1813.

[18] Farington, 'Diary', 7 April 1813.

[19] For Wilkie's reactions, see: William T. Whitley, *Art in England* 1800–1820 (Cambridge, 1928), p.209.

[20] Farington, 'Diary', 27 April 1813. The publication was: *Some Account of Mary Thomas in Merionethshire, Who Has Existed Many Years Without Taking Food: And of Ann Moore, Commonly Called the Fasting Woman of Tutbury Accompanied with Portraits and Illustrative Etchings* (London, 1813). The book was based on information Ward collected on these two women from 1802 through 1811. Ann Moore was proved to be a fraud shortly after Ward published his study which was intended as a 'short narrative of some singular abberations in the animal economy'. Mary Thomas died before the work was published.

[21] Anon., 'Sporting Subjects in the Exhibition of the Royal Academy This Year', *Sporting Magazine*, 42 (1813), 79.

[22] Lister Correspondence, Bradfer-Lawrence Collection. There is no record of a horse painting having been purchased, and in view of Lord Ribblesdale's financial problems at this time (see note 23 below), it seems unlikely that one was bought. Although *The Art Journal*, 11 (1849), 181, stated that Lister had been a pupil of Ward, I have found no evidence of his having studied with the artist on a formal basis, in fact the documents quoted above in the Chronology suggest the opposite. Lister did, however, study with Philip Reinagle and Thomas Barker of Bath.

[23] *Ibid.* Presumably this refers to the Gordale commission. The Lister Correspondence from 1812 and 1813 reveals that Lord Ribblesdale, along with much of the country, was experiencing financial problems. Because of these, he may have tried to cancel the commission at a time when he was also considering dismissing some servants and giving up the hounds.

[24] *Ibid.*

[25] Ward, 'Account Book', (p.59 left). See Note 20 above.

[26] *Ibid.*, (p.59 right).

[27] Lister Correspondence, Bradfer-Lawrence Collection. The meaning of this letter has not been established. Since the painting was basically paid for by this time, it is unlikely that Lord Ribblesdale was still considering cancelling the commission. It is possible that the remark has to do with the decision not to build the addition to the house for which the painting was planned.

[28] Ward, 'Account Book', (p.59 right).

[29] Lister Correspondence, Bradfer-Lawrence Collection.

[30] *Ibid.*

[31] Ward, 'Account Book', (p.59 right). C. Reginald Grundy, *James Ward, R.A.* (London, 1909), p.44 (No.330) states that Lord Ribblesdale paid £600 for the picture; but he does not cite his source.

[32] Lister Correspondence, Bradfer-Lawrence Collection.

[33] The three other paintings were: 'Portraits of Prince Platoff's Favourite Charger and of Four of his Cossacks' (Duke of Northumberland Collection); 'Portraits of Two Extraordinary Oxen, the Property of the Earl of Powis' (Paul Mellon Collection, Yale Center for British Art); and 'Portraits of a Charger and a Favourite Poney, the Property of Lord Stewart' (unlocated).

[34] Lister Correspondence, Bradfer-Lawrence Collection.

[35] *Ibid.*

[36] *Ibid.*

[37] *Ibid.*

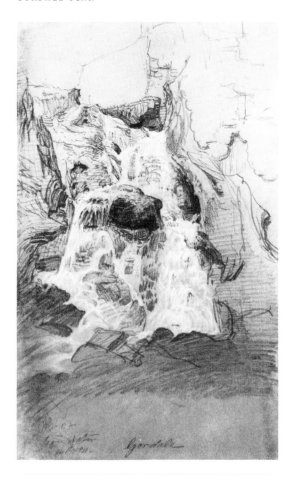

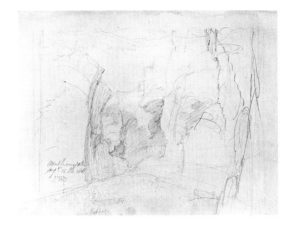

CATALOGUE NOTE

Dimensions are given in inches followed by millimetres in brackets, height precedes width. Titles in most cases are descriptive or traditional; quotation marks are used when the work is so inscribed; square brackets indicate material added by me to distinguish works with identical or similar titles. Dates in brackets represent my chronology for the work; all other dates are inscribed. Square brackets in the inscriptions identify my notations and < > additions. If a work descended in the artist's family, the descent has not been traced generation by generation in the provenance.

1 **The Falls – Gordale Scar** 14 August 1811
Black and white chalk on grey paper
$16\frac{1}{16} \times 10\frac{3}{4}$ (427 × 273)
Inscribed, lower left: J. Ward [monogram] RA
[signature added later]/<Mal>ham Water/<Aug>.ᵗ
14th 1811–; lower centre: Gordale [added later].
Provenance: (?); anonymous seller, sold Christie,
5 May 1974, lot 80, bought by Anthony Reed.
Anthony Reed

Ward arrived at Gisburn on 6 August. This is the first dated drawing of the Scar so far located. Drawn from a point very close to the waterfall perhaps from atop an outcropping on the right side, this sketch focuses on the lower part of the cataract, a feature Ward exaggerated for effect in the final painting. Little attention is given to the surrounding landscape elements.

Ward did not include either in this drawing or in the finished work and interim studies the hole in the upper part of the cataract, created about 1730 during a storm. This feature appears in other early nineteenth century representations (see figs 1–4). By excluding this element, Ward may have been consciously placing the scene in a time before the fissure occurred, to a time which predated the remembrance of his viewers and thus, in essence, to ancient times.

2 **Gordale Scar** 15 August 1811
Pencil on cream paper
$10\frac{5}{8} \times 14\frac{3}{8}$ (270 × 365)
Inscribed, lower left: Malham Water/Aug.ᵗ 15th 1811/
J. Ward [monogram] [signature added later]; lower
left centre: Gordale [added later].
Provenance: By descent in the artist's family to
Mme E. Arnold.
Madame E. Arnold, Geneva, Switzerland

The first overall dated compositional study for the painting, this perspective drawing of the Scar treats the view in terms of mass and planes. By this time, Ward

must have visited most of the sites in the area since his view is less an accurate transcription of the Scar itself than a synthesis of visual impressions of the geological features of the area, including nearby Malham Cove. There are faint line drawings of the bull on the right and cattle on the left.

3 **'First Sketch for Gordale Scar'** [mid August 1811]
Charcoal and white chalk on brown paper
11 × 18⅛ (279 × 460)[1]
Inscribed, lower right: JWD RA [signature added later]; on verso, overfold cover: First Sketch for Gordale Scar [added later].
Provenance: Probably by descent in the artist's family to Edith Winifred Jackson, his great granddaughter; with a dealer in West Ealing from whom purchased by Thomas H. Knowles, 1932;[2] by descent to his son, T.W. Knowles, 1956; by gift to Prudence Summerhayes, 1956.
Bibliography: Prudence Summerhayes, 'Great Picture in Obscurity: James Ward, R.A. and *Gordale Scar*', Country Life, CLXII, (21 July 1977), p.155 (illus. p.154).
Prudence Summerhayes

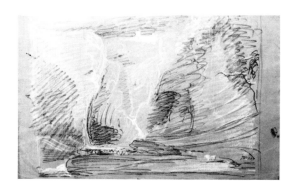

Despite the inscription added later by the artist, this drawing was probably executed after the perspective sketch dated 15 August (Cat.no.2) since it is a fully realized, confident composition. As a chiaroscuro study, this work defines the areas of light and dark at the same time that it establishes the basic components of the final composition – waterfall, large field in the foreground, bull on the right side, stream on the left, and dramatic sky above. Ward even indicated the striations in the limestone wall on the right that he employed in the final composition to suggest its amphitheatre-like grandeur and to emphasize its magnitude.

[1] The drawing appears on only one-half of a folded sheet of paper, measuring 22⅜ × 18⅛ (568 × 460)
[2] This information was given to Prudence Summerhayes by Thomas H. Knowles in a letter dated 15 November 1955

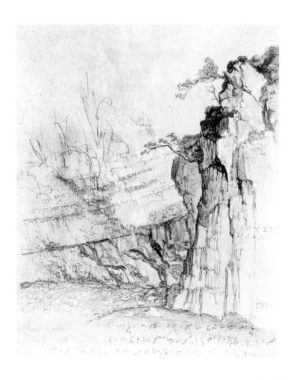

4 **'Gordale' – A Study** 16 August 1811
Oil washes over pencil with ink on cream paper
11 1⅖ × 9⅝ (303 × 244)
Inscribed, lower right: JWD. RA [signature added later]; centre right: [shorthand notes]; lower centre: [shorthand notes]; lower left: Malham Water/<Au>g^t 16^th 1811; lower centre: Gordale.
Provenance: By descent in the artist's family to Mrs E. D. Sanderson.
Mrs Eva Sanderson

Although the details are very specific, the formation portrayed has not been positively identified with a particular part of the Scar; however, the drawing may depict the end of the projection shown in Cat.no.5 and the wall of the cavern beyond. The sweep of the striations, a feature emphasized in the final painting and in the 'first sketch' (Cat.no.3), support such an identification.

The oil washes were probably added later over the pencil sketch as in the case of Cat.no.5; and the work, like several others in the exhibition, appears from the cropping of the image to be cut from a larger sheet.

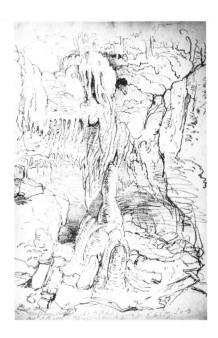

5 Sketch for Gordale Scar [Panoramic View]
[16 (?) August 1811]
Oil washes over pencil on cream paper, varnished and retouched[1]
$12\frac{3}{8} \times 16\frac{3}{4}$ (314 × 425)
Inscribed on verso, centre: Gordale Scar-/ Craven. Yorkshire.
Provenance: By descent in the artist's family to Henrietta Ward (Mrs E. M. Ward), his grand-daughter, from whom purchased by the Tate Gallery, 1922.
Tate Gallery (3703)

This view was taken from part way up the left-hand side of the valley on the approach to the waterfall. The ascent is arduous and the drawing therefore demonstrates Ward's determination to experience the Scar in its totality from various points even at the expense of considerable physical effort. Although the sketch establishes the relationship between the cataract and the surrounding cliffs that Ward incorporated in his final composition, it also faithfully records how the projection on the right blocks the visitor's view of the Scar from a distance. By eliminating this formation from his painting, Ward was able to enlarge the arena of action and dramatize the sublimity of the scene. The style and use of oil washes suggest that this drawing may have been done on the same day as Cat.no.4.

[1] This work has long been considered watercolour; however, close examination of the work indicates that it was done with thin oil washes, a medium Ward frequently employed at this time. According to the Tate's Conservation Department, there is indication that the work was then varnished and retouched by the artist.

6 'Lead Mine – Malham Water' 17 August 1811
Graphite on cream paper
$15\frac{5}{16} \times 10\frac{7}{8}$ (389 × 276)
Inscribed, lower left: Lead Mine/ Malham Water/ Augt 17th 1811 – J. Ward [monogram] RA [signature added later]; lower centre: [shorthand notes].
Provenance: Probably by descent in the artist's family to Edith Winifred Jackson, his great granddaughter; with a dealer in West Ealing from

whom purchased by Thomas H. Knowles, 1932;[1]
by descent to his son, T. W. Knowles, 1956; by gift
to Prudence Summerhayes, 1956.
Prudence Summerhayes

Although not a drawing dealing directly with the Scar,
this work and Cat.no.7 reveal Ward's fascination with
the unusual geological formations of the area. Discovered
only a few years before these sketches were made, the
lead mines as depicted by Ward take on an unearthly
quality which seems to be reflected in the artist's inter-
pretation of the limestone found in the Scar proper.
Certainly, Ward's rendering of the elongated stalactites
and stalagmites is echoed in his emphatic treatment of
the rock formation in the final composition.

[1] This information was given to Prudence Summerhayes by Thomas
H. Knowles in a letter dated 15 November 1955.

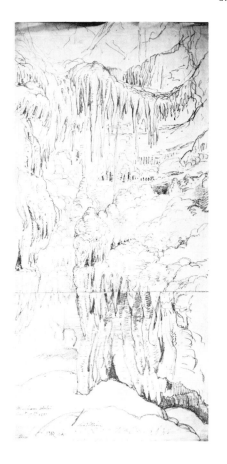

7 'Malham Water – Lead Mine' 17 August 1811
Graphite on cream paper
$22 \times 10\frac{3}{4}$ (559 × 273)[1]
Inscribed, lower left: Malham Water/ Aug. 17th 1811/
one in colour [added later] / Mal; lower left: J Ward
[monogram] RA [signature added later]; lower centre:
Lead Mine; lower centre: [shorthand notes].
Provenance: Probably by descent in the artist's
family to Edith Winifred Jackson, his great-
granddaughter; with a dealer in West Ealing from
whom purchased by Thomas H. Knowles, 1932;[2]
by descent to his son, T.W. Knowles, 1956; by
gift to Prudence Summerhayes, 1956.
Prudence Summerhayes

Ward frequently made colour notations in shorthand on
his drawings as did other artists of the time; for example,
Robert Hills, a friend of Ward, used the same shorthand
system.

[1] Total length of two attached sheets.
[2] This information was given to Prudence Summerhayes by Thomas H.
Knowles in a letter dated 15 November 1955.

8 'Gordale' – Details of Rocks near Waterfall (?)
19 August 1811
Graphite on cream paper
$10\frac{3}{4} \times 15\frac{1}{2}$ (273 × 393)
Inscribed, lower right: Gordale / J Ward [monogram]
RA [signature added later] / Aug'19th 1811.
Provenance: By descent in the artist's family to
Mme E. Arnold.
Madame E. Arnold, Geneva, Switzerland

The exact formations which inspired these sketches have
not been positively identified; however, it is possible that
the left-hand area is the left side of the fall at the point
where the cataract divides to make its final plunge for the

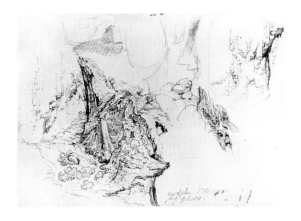

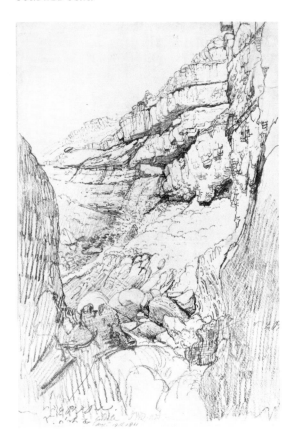

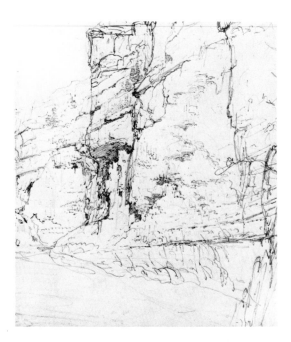

horn-like element is still to be found (see fig.11d). The void in the centre of the sheet would then be the water; the details on the right, the boulder and rocks of the corresponding bank. The sketch separated from the rest in the upper right-hand corner of the sheet could be the indentation in the cavern wall on the right above the falls. In view of the lack of a firm geological context, the identification must remain conjectural although when this work is considered in connection with the drawings on the verso of Cat.nos 14 and 15 such a possibility becomes more likely. With their dramatic use of line to create precise, discreet forms of a strange unearthly character, the sketches on this page bear an interesting resemblance to drawings by Leonardo da Vinci in the Royal Collection, which Ward could have known.

9 Gordale Looking Out 19 August 1811
Graphite on cream paper
15⅛ × 10½ (384 × 267)
Inscribed, lower left: [colour notes in shorthand]/
Gordale/ Aug' 19th 1811.
Provenance: (?); with Colnaghi from whom
purchased by Douglas H. Gordon, 1937.
Exhibition: The William Hayes Ackland Memorial
Art Center, Chapel Hill, North Carolina, *English
Watercolors and Drawings* 1700-1900, 21 September-
26 October, 1975, No.69.
Douglas Gordon

Ward must have been standing on a high ledge, with his back to the falls, when he executed this work. In fact, he may have returned to the spot from which he drew Cat. no.1 to execute this sketch; however, the vantage point is ambiguous. At first glance the sketch seems to be taken from above the falls looking down and out; but, the formations depicted can only be viewed from in front of the falls on an outcropping on the left. Although this view was not incorporated in the final version, it further demonstrates Ward's desire to experience the Scar from a variety of angles so that he would be better able to translate his visual and tactile responses to the site onto canvas and transmit these feelings to the viewer of the painting. The heavy, thick blacks used to define the rock formations relate this work to the two drawings of the lead mines (Cat.nos 6 and 7) done two days earlier.

10 Gordale – The Overhang [19 (?) August 1811]
Pencil on cream paper
8⅝ × 7¹³⁄₁₆ (219 × 198)
Verso: watercolour of a seated young boy, detail
taken from 'The Recruit'.
Provenance: (?); the property of the late H.P.
Broadbent, sold Sotheby, 23 January 1963, lot 71,
bought by H. Noel Whiting; by descent to
anonymous seller, sold Sotheby, 13 March 1980,
lot 72¹ (illus.), bought by Anthony Reed.
Anthony Reed

The overhang was considered one of the most awesome aspects of the Scar. Thomas Gray, for example, found standing under the 'dreadful canopy' an horrific experience.[2] It is not surprising, therefore, that Ward made a drawing of this feature, although it is hidden in the gloom in Ward's various painted versions. From the way in which it is cropped, the drawing clearly is cut from a larger sheet that included more of the Scar.

[1] The provenance given in the Sotheby catalogue is inaccurate. Although H. Noel Whiting received a number of works by James Ward from Capt. Claude Ward Jackson, he purchased others. The information on the provenance of this drawing was given to the writer by Mr Whiting in 1970.
[2] Thomas Gray, 'Journal in the Lakes', *Works* (London, 1884), I, 277-8. Gray visited the Scar in 1769 but his observations were not published until 1775, a few years after his death.

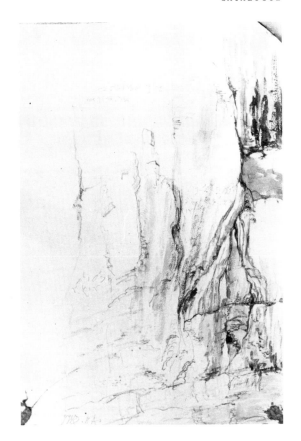

11 Cliff Study – Gordale Scar [Mid August 1811]
Watercolour over black chalk on cream paper
$13\frac{1}{8} \times 9\frac{9}{16}$ (333 × 243)
Inscribed, lower left: J Ward [monogram] RA [signature added later]; centre top: [shorthand notes]; centre right: [shorthand notes].
Verso: A full-length pencil drawing of a standing rustic holding a pole, leaning on a fence.
Provenance: (?); with Herbert A. Robinson (?); the Honourable Sir John Ward, K.C.V.O. by April, 1912; by descent to the present owner.
Private Collection

The exact location of this detail has not been determined, but it documents, as do several other drawings in the exhibition, Ward's fascination with the limestone and his desire to express the colour, texture, and patterning of the formation in the final work. The colour was probably added later, perhaps when Ward was still at Gisburn Park. Because of the way in which the drawing is cropped, it is likely that the sheet was cut down.

12 Study for Gordale Scar [View of the Falls]
[Mid August 1811]
Oil over charcoal on brown paper laid on board
$12\frac{9}{16} \times 16\frac{7}{8}$ (318 × 429)
Provenance: (?); R.W. Howes from whom purchased by the Tate Gallery (Lewis Fund), 1907.
Exhibition: Arts Council of Great Britain, *James Ward*, 1960, No.16 (illus. pl.IV).
Tate Gallery (2142)

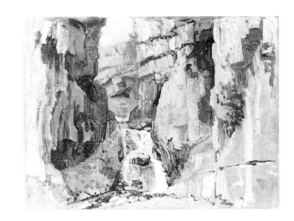

As is evident from a recent photograph of the Scar (fig.11d), this view of the cataract is about the only one possible from straight ahead, given the narrowness of the canyon at this point. It approximates the view presented in the earliest dated sketch of the falls (Cat.no.1); but here the cataract is shown from a position slightly further back in the narrow canyon which permits a more ex-

pansive, horizontal treatment of the landscape. While the light and warm colours of this sketch reduce the sublime effect of the scene, the towering, jagged cliffs still convey a sense of the monumental, awesome nature of the Scar. A close-up view of the falls, comparable to this one, was incorporated in the final version thereby exaggerating the size of the cataract and the valley in front of it.

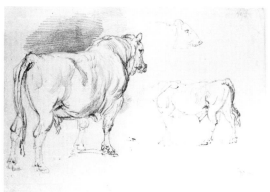

13 Three Studies of a Bull 22 August 1811
Pencil on cream paper
$7\frac{1}{4} \times 10\frac{5}{8}$ (184 × 270)
Inscribed, lower right: JWD. RA [signature added later] / Gisburn Park / Aug.t 22d 1811.
Annotated, upper right: 1/11/6[1].
Provenance: (?); with Grundy and Robinson from whom purchased by the Honourable Sir John Ward, K.C.V.O., July 1907; by descent to the present owner.
Exhibition: Grundy and Robinson, *James Ward,* June, 1907.
Private Collection

There are several dated drawings of cattle from 22 and 23 August (see Cat.nos 14-19). This sheet as well as Cat. nos 14 and 15 effectively demonstrate Ward's practice of sketching quickly on a single page the same animal (or parts of the same animal) from different angles.

[1] These figures are undoubtedly the price.

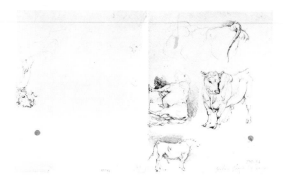

14 Bull Studies (1) 22 August 1811
Pencil on cream paper
$11\frac{1}{16} \times 8\frac{7}{8}$ (282 × 226)
Inscribed, lower right: JWD. RA [signature added later] / Gisburn Park Aug.t 22 1811
Verso: Pencil sketch of detail of Gordale Scar
Provenance: (?); purchased by the Fitzwilliam, 1885.
Fitzwilliam Museum, Cambridge

These studies display Ward's mastery of the quick sketch. With a few strokes of shading, perhaps added later to bring out certain qualities, he silhouettes the forms and vitalizes even a minor detail such as the animal's tail in the top drawing. The sketch on the verso resembles Cat.no.8, dated 19 August, in its interest in the jagged, pointed quality of the limestone; therefore, it probably was made on the same day when Ward returned to record other aspects of the site (Cat.no.9). The most fully realized portion (far left centre) is a depiction of the waterfall from a distance. This fragment matches in style and line the right hand portion of Cat.no.15 and, despite the differences in size, probably once formed a single large sheet or were two facing pages of the same sketchbook.

15 **Bull Studies** (2) 22 August 1811
Pencil on cream paper
$9\frac{7}{8} \times 6\frac{1}{16}$ (250 × 154)
Inscribed, lower centre: JWD. RA [signature added
later] / Gisburn Park Aug! 22ᵈ 1811
Verso, Pencil sketch of left side of Scar near waterfall.
Provenance: (?); anonymous seller, sold Sotheby,
10 July 1980, part of lot 22, bought by Anthony Reed.
Anthony Reed

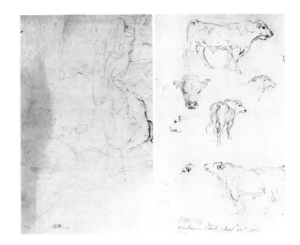

The foreshortened bull in the centre of the sheet may
have been the inspiration for the animal that dominates
the left foreground of 'Tabley Lake and Tower' (Cat.
no.37). The sketch on the verso is a slight, tentative
rendering of the left side of the Scar near the falls.[1] As an
extension of the verso of Cat.no.14, it was probably done
on 19 August.

[1] I am grateful to Anthony Reed for this suggestion, which sub-
sequently lead to the identification of the verso of Cat.no.14.

16 **Five Studies of Cows** 23 August 1811
Pencil on cream paper
$6\frac{9}{16} \times 7\frac{7}{16}$ (167 × 189) [irregular]
Inscribed, lower right: JWD. RA [signature added
later] / Gisburn Park/Aug! 23ᵈ 1811.
Provenance: By descent in the artist's family to
Claude Werner.
Mr Claude Werner, Lausanne, Switzerland

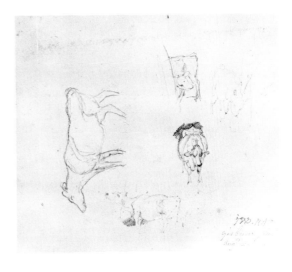

This is one of several cattle studies Ward made at
Gisburn Park on 23 August (Cat.nos 16–19). The cow,
looking head on, in the right centre of the sheet appears
as one of the focal points in the main body of cattle
depicted in the final work. The fact that a cow stands in
a similar position in the earlier 'Cattle-piece' (Cat.no.36)
underscores how Ward repeatedly employed certain
poses to give variety to his groupings of cattle; the cow
is not so much a particular animal as a formal device in a
composition although the pose is based on observations
from nature.

17 **Studies of Cows** 23 August 1811
Pencil and watercolour on cream Whatman paper
laid down on green paper
$10\frac{1}{4} \times 7\frac{1}{16}$ (273 × 183)
Inscribed, lower right: [shorthand notes]; lower right:
JWD. RA [signature added later] / Gisburn Park.
Aug! 23ᵈ 1811.
Provenance: (?); anonymous seller, sold Sotheby,
18 December 1963, part of lot 201, bought by
Colnaghi; with Colnaghi from whom purchased by
Paul Mellon, 1964.

Bibliography: Judy Egerton and Dudley Snelgrove, *British Sporting and Animal Drawings c.1500-1850: The Paul Mellon Collection* (The Tate Gallery for the Yale Center for British Art, 1978), p.98, no.24. *Paul Mellon Collection, Upperville, Virginia*

Although none of these studies can be paired exactly with cattle in 'Gordale Scar', similar reclining cows appear in several places in the work. The colour was probably added later, perhaps when Ward was still at Gisburn.

18 Cattle Studies 23 August [1811]
Watercolour over pencil on cream paper
$6\frac{3}{4} \times 11\frac{3}{8}$ (172 × 288) [sight]
Inscribed, lower right: JWD. RA [signature added later]/Gisburn / Aug.t 23d
Provenance: Alfred Morrison, by about 1880; by descent to the present owner.
Private Collection

None of these studies can be identified with any particu-

lar cattle in 'Gordale Scar'. Ward probably referred to these and other drawings of cattle when painting the final canvas to recall general characteristics of the Gisburn herd as well as specific poses and markings.

19 Cow Studies 23 August 1811
Pencil on white paper
$7\frac{5}{16} \times 8\frac{3}{4}$ (186 × 222)
Inscribed, lower right: JWD. RA [signature added later]/ Gisburn Park/ Aug.t 23d 1811 –
Owner's mark: (TEL)
Provenance: (?); T.E. Lowkinsky; by descent to Justin Lowinsky from whom acquired by Paul Mellon, 1963.
Paul Mellon Collection, Upperville, Virginia

Although the large cow study on the far left could have been the source for one of the cattle in the centre of the herd, such a sketch probably acted as a general *aide-mémoire* rather than served as a prototype for a specific animal in the finished work. Some of the motifs found in these drawings recur in later compositions.

17

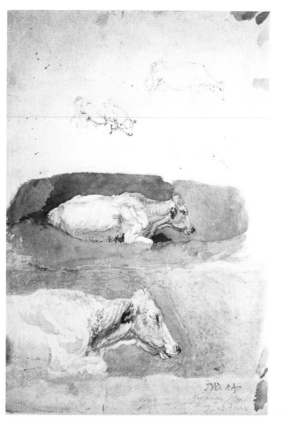

18

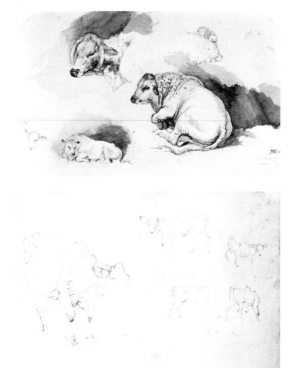

19

20 Cattle Studies – Tytherton July 1811
Pencil on cream paper
$5\frac{3}{8} \times 7\frac{1}{2}$ (136 × 190)
Inscribed, lower right: Tytherton/ July 1811 /
JWD. RA [signature added later]
Provenance: By descent in the artist's family to
Claude Werner.
Mr Claude Werner, Lausanne, Switzerland

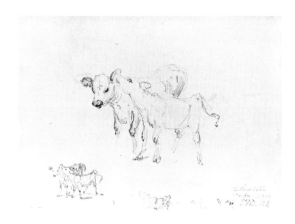

Despite the inscribed location, the motif of a calf
nibbling or licking the ear of another animal was incor-
porated into the final composition. Like Cat.no.21, it
demonstrates that the cattle or groupings depicted in
'Gordale Scar' were not necessarily based on sketches
Ward made of Lord Ribblesdale's famous wild herd.

21 Studies of Cattle at Tabley 24 July 1811
Pencil and watercolour on cream paper
$7\frac{1}{2} \times 10\frac{7}{8}$ (191 × 276)
Inscribed, lower left: JWD. RA [signature added later]/
Tabley/ July 24th 1811.
Provenance: (?); with Colnaghi from whom
purchased by Robert Witt, about 1925; bequeathed
to the Courtauld Institute of Art, 1952.
Courtauld Institute Galleries (Witt Bequest)

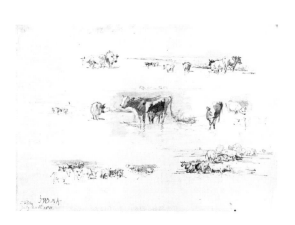

Unlike the cattle studies done at Gisburn Park which
tend to focus on the individual, these sketches explore
the patterns created by natural groupings, an essential
consideration in a painting such as 'Gordale Scar' con-
taining a large number of cattle. The central group
of three animals appears at the far right of the main herd
in the painting; and the calf study to the right of this
group may have served as a point of departure for the
animal behind the cow on the far right near the bull.

22 Deer Studies (I) [*c*.mid 1811]
Pencil on white paper
$7\frac{3}{16} \times 8\frac{11}{16}$ (182 × 224)
Inscribed, far right centre: JWD. RA [signature added
later].
Provenance: Probably by descent in the artist's
family to Edith Winifred Jackson, his great grand-
daughter; with a dealer in West Ealing from whom
purchased by Thomas H. Knowles, 1932;[1] by
descent to his son, T.W. Knowles, 1956; by gift to
Prudence Summerhayes, 1956.
Prudence Summerhayes

None of the studies of deer (see Cat.nos 22–27) are in-
scribed as being executed at Gisburn although Lord
Ribblesdale did maintain a park. Ward did, however, do
a number of drawings of deer at Wichnor (or Wychnor)
an estate of his patron, Theophilus Levett, which he
visited in September and October, 1811. These studies,
as well as the other sketches of deer relevant to 'Gordale

Scar', may have been executed there. This sheet contains several groupings of animals incorporated in the final composition, including a faint sketch of the fighting stags in the lower right.

[1] This information was given to Prudence Summerhayes by Thomas Knowles in a letter dated 15 November 1955.

23 Deer Studies (2) [c.mid 1811]
Pencil on cream paper
$7\frac{1}{8} \times 8\frac{1}{3}$ (181 × 223)
Inscribed, upper right: [shorthand notes]; lower right: JWD. RA [signature added later].
Provenance: Probably by descent in the artist's family to Edith Winifred Jackson, his great grand-daughter; with a dealer in West Ealing from whom purchased by Thomas H. Knowles, 1932;[1] by descent to his son, T.W. Knowles, 1956; by gift to Prudence Summerhayes, 1956.
Bibliography: Prudence Summerhayes, 'Great Picture in Obscurity: James Ward, R.A. and *Gordale Scar,' Country Life* CLXII (21 July 1977), Illus. p.155.
Prudence Summerhayes

The central group appears in the final painting, and some of the other studies may have been the source of inspiration for the deer on the hillside to the left of the waterfall.

[1] This information was given to Prudence Summerhayes by Thomas Knowles in a letter dated 15 November 1955.

24

24 Studies of Deer [c.mid 1811]
Pencil on cream paper
$7\frac{1}{2} \times 6\frac{5}{16}$ (190 × 160)
Inscribed, lower left: JWD. RA [signature added later]
Provenance: (?); purchased by the Fitzwilliam, 1885.
Fitzwilliam Museum, Cambridge

The standing deer with the bent head in the lower left quadrant appears in 'Gordale Scar' just to the left of the waterfall. Other studies from this sheet may have served as sources for representations of deer in either the finished sketch or the final version.

25 Six Studies of Deer [c.mid 1811]
Pencil on cream paper
$7\frac{11}{16} \times 6\frac{7}{16}$ (201 × 163) [irregular]
Inscribed, lower left: JWD. RA [signature added later]
Annotated, upper left: No.23 / 4/4[1].
Verso: Pencil study, bust length of a young rustic, and three studies of pigs.
Provenance: (?); with Grundy and Robinson (?); the Honourable Sir John Ward, K.C.V.O.; by descent to the present owner.
Private Collection

Although the stag in the upper left may relate to the animal on the right at the head of the phalanx of deer, lower right in 'Gordale Scar', and to the similarly positioned creature in the finished sketch, most of these studies as well as many on the other sheets here exhibited probably were used by Ward as a general reference on natural stances in composing the groups of deer rather than as sources for individual animals.

[1] These figures undoubtedly represent a dealer's inventory number and price.

26 Fighting Stags (1) [c.mid 1811]
Pencil on cream paper
$7\frac{3}{8} \times 10\frac{5}{16}$ (187 × 260)
Inscribed, lower left: JWD. RA [signature added later]
Provenance: By descent in the artist's family to Henrietta Ward (Mrs E.M. Ward), his grand-daughter; private collection; with Spink; Sir Robert Witt, who presented it to the Tate Gallery through the N.A.C.F., 1940.
Bibliography: Geoffrey Grigson, 'James Ward Reconsidered', *Country Life,* CVII (13 January 1950), p.96 (illus.).
Exhibition: C.E.M.A., *Two Centuries of British Drawings from the Tate Gallery,* 1944, No.81; Arts Council of Great Britain, *James Ward,* 1960, No.76.
Tate Gallery (5161)

25
26

Conflict between animals is a common theme of Romantic art. Ward treated the subject on several occasions as did George Stubbs, Sir Edwin Landseer, and other British artists of the late eighteenth and early nineteenth centuries. Here, the schematic, linear treatment of the fighting stags interprets the primeval confrontation with archaic simplicity. Because the deer almost seem to be pushing against the physical limits of the sheet, the composition heightens the tension and energy of the struggle.

27 Fighting Stags (2) [c.mid 1811]
Pencil on white paper
$4\frac{7}{8} \times 7\frac{15}{16}$ (124 × 202)
Inscribed, lower right: JWD. RA [signature added later]
Provenance: (?); Randall Davis; Miss Dido Davis; sold Sotheby, 19 March 1981, lot 36, bought by Anthony Reed.
Anthony Reed

Because shading has been introduced to create a three-dimensional form, this sketch probably represents a slightly later working of the fighting stags drawn linearly in Cat.nos 22 and 26. It is possible that the outlines of the animals on this sheet were made at the same time as the two studies cited above and that shading was added afterward. The size of the page suggests this work may have been cut from a larger piece of paper.

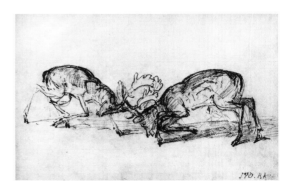

[47]

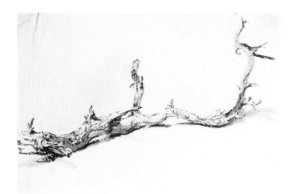

28 A Study of a Tree Branch 1798 (?)
Watercolour over pencil touched with Plaster of
Paris (?) on grey paper
$6\frac{3}{16} \times 9\frac{7}{16}$ (157 × 241) [irregular]
Watermark: Britannia
Inscribed, lower right: J.W.; verso, lower right:
Plaister of P touched [sic] upon same / that changed
$--$ Decm 5 - 98 $--$
Provenance: (?); the Honourable Sir John Ward,
K.C.V.O.; by descent to the present owner.
Private Collection

Ward undoubtedly sketched shrubs and plants at
Gordale,[1] but this early drawing is the only study so far
identified as being directly related to the painting. While
there are differences between the large fallen branch
depicted here and the one on the bank at the far left in
'Gordale Scar', this work nevertheless seems to be the
source for the element in the painting. Utilizing draw-
ings or paintings made years before in the creation of
later works was not an uncommon practice for Ward,
and this is a case in point (see also Cat.nos 29 and 30).

Ultimately derived from seventeenth century proto-
types, elements such as a fallen tree or branch frequently
occur in Ward's landscapes,[2] and in the work of other
artists of the period. Serving as formal devices, they also
dramatize the destructive power of nature. In 'Gordale
Scar', the fallen branch adds to the painting's aura of
desolation at the same time that it helps to bracket the
left side of the composition and leads the eye back to-
ward the cattle and falls.

[1] The drawing of Herb Paris in the Brinsley Ford Collection (London)
stylistically belongs in the 'Gordale Scar' period. While the plant
does appear in the final picture, there is no visual or documentary
evidence that the Ford sketch was made at Gordale or referred to by
the artist when he was working on the painting.
[2] Other examples include: 'Bulls Fighting with a View of St. Donat's
in the Background' (1803, Victoria and Albert Museum); 'Harlech
Castle' (1808, Tate Gallery); and 'Kenilworth Castle' (1840, Paul
Mellon Collection, Yale Center for British Art).

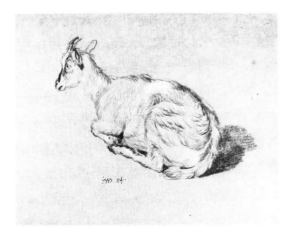

29 A Reclining Goat [1795-1810]
Black chalk heightened with white on grey paper
$10\frac{5}{8} \times 12\frac{1}{2}$ (270 × 318)
Inscribed, left of centre: JWD. RA [signature added
later]
Provenance: (?); Peter Cochrane.
Peter Cochrane

The presence of a single goat in 'Gordale Scar' as the
visual link between the guardian bull and the fighting
stags is unexpected. In the Bradford version, several
animals (goats?) occupy comparable space in the com-
position. Ward's inclusion of only one goat, the animal
mentioned by Gray in his journal[1] and referred to by
Whitaker as 'lately banished from the sides of Gordale'[2]
seems more than coincidental. Perhaps Ward intended

its singularity as a pointed allusion to the recent disappearance of the animal from the area or as a reinforcement of the notion of Gordale's prehistoric past.

The dating of this work is problematic. The soft drawing of the animal, although a product of the chalk, is more suggestive of Ward's earlier style; however, he also used similar paper and medium in sketches from the first decade of the nineteenth century. A related drawing was recently sold at auction.[3]

[1] Thomas Gray, 'Journal in the Lakes,' *Works* (London, 1884), I, 277.
[2] Thomas D. Whitaker, *The History and Antiquities of Craven* (1805; rpt. London, 1812, p.207.
[3] Anonymous sale, Christie, 3 August 1976, lot 33.

30 Wild Bull [*c.*1800–02]
Oil over pencil on panel
$15\frac{3}{8} \times 19\frac{5}{8}$ (390 × 499)
Inscribed, lower left: JW. RA. [signature added later]
Provenance: Purchased from the artist in 1822 (?) by William Wigram (d.1858); by descent in family to Fitzwygram Trust
Exhibition: (?) 6 Newman Street, London, 1822, No.14 or 94.
Private Collection

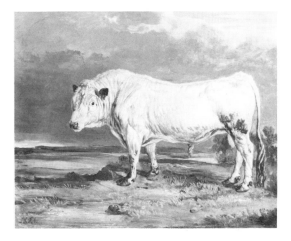

By tradition, the subject of this painting is a 'wild bull in Lord Ribblesdale's Park' and is so identified in family papers going back to the nineteenth century. However, the markings of the animal, especially the black ears, show that it cannot be a bull from the Gisburn herd of wild cattle described by Bewick as being 'perfectly white, except the inside of the ears, which are brown,'[1] and by Whitaker as 'white, save the tips of their noses, which are black.'[2] Moreover, the style places the painting at the turn of the century (see Cat.no.31) when Ward was involved in a project to record the various breeds of livestock in England.[3] Finally, it should be noted that the bull here portrayed appears in a painting dated 1802 (?)[4] at the Winnipeg Art Gallery, and in *'Cattle-piece'* (Cat.no.36) of 1807. The traditional title of this work was probably assigned to it after 'Gordale Scar' was purchased by the National Gallery with a degree of notoriety. Despite this reidentification, the stance and expression of the wild bull in 'Gordale Scar' clearly owes a debt to this earlier work, and it seems likely that the artist referred to it while engaged on the Ribblesdale commission.

The animal depicted may be 'a bull of the original wild British breed, the property of Thomas Levett, Esq.,' Ward's long-time patron and friend. Two paintings of this basic description and title were exhibited for sale by the artist at his house in Newman Street in 1822 along with one hundred other works including one of Lord Ribblesdale's bull.[5] Since another painting by Ward in the Fitzwygram Trust was also exhibited at this time, it

seems reasonable to suggest that both were purchased from the exhibition by William Wigram.[6] The signature was probably added by the artist on the occasion of the exhibition.

[1] Thomas Bewick, *A General History of Quadrupeds*, (Newcastle upon Tyne, 1791), p.35 note.
[2] Thomas D. Whitaker, *The History and Antiquities of Craven* (1805; rpt. London, 1812), p.37.
[3] For the well-documented history of the Boydell project, see: G. E. Fussell, *James Ward, R.A.* (London, 1974), pp.72-8, 82-115; also see: C. Reginald Grundy, *James Ward, R.A.* (London, 1909), pp.xxx-xxxi.
[4] The date of the painting called 'The Great Bull' is worn, but it seems to be 1802, a date consistent with its style and signature.
[5] *Descriptive Catalogue of Pictures Painted by James Ward, Esq., R.A., now exhibiting at No.6 Newman Street* (London, 1822), nos 14, 90 and 94.
[6] The painting is: 'Portrait of a Terrier, the property of the late Charles Sturt, Esq.', no.85.

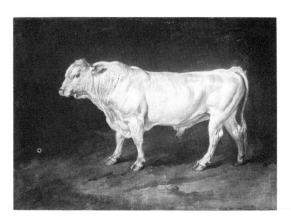

31 A Young Bull[1] [August 1811]
Oil over pencil on paper, laid on canvas
12 × 17 (305 × 432)
Provenance: (?); Cartwright Bequest to Wolverhampton Art Gallery and Museums, 1887.
Bibliography: Prudence Summerhayes, 'Great Picture in Obscurity: James Ward R.A. and *Gordale Scar,' Country Life*, CLXII, (21 July 1977), illus. p.155.
Wolverhampton Art Gallery and Museums

Younger than the bull depicted in 'Gordale Scar', the animal portrayed here can be identified with the Gisburn herd on the basis of its colouring (see Cat.no.30). Moreover, it is close in conception to the bull in the Bradford version (Cat.no.34). The identification is further substantiated by the style of the painting, which places the work after 1809, when with the precedent of the Elgin Marbles before him, Ward first began to articulate the veins in his portraits of horses and cattle. This feature does not, for example, appear in Cat.no.30 nor in the white bull depicted in *'Cattle-piece'* of 1807 (Cat.no.36). Moreover, the palette and broad brushstrokes used to suggest the earth in this study are also found in the finished sketch.

[1] The traditional title for the painting is: 'A Prize Bull'.

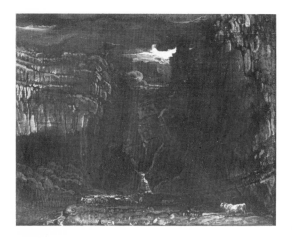

32 Oil Study for Gordale Scar (I) [Mid August 1811]
Oil on panel
7 × 9⅛ (178 × 232)
Provenance: (?); with Sidney Sabin from whom purchased by Paul Mellon, 1964; by gift to the Yale Center for British Art, 1977.
Exhibition: Royal Academy of Arts, London, *Painting in England* 1700-1850: *From the Collection of*

Mr and Mrs Paul Mellon, Winter 1964-5, No.125;
Yale University Art Gallery, New Haven, *Painting
in England* 1700-1850: *From the Collection of Mr and
Mrs Paul Mellon*, 15 April - 20 June, 1965, No.212.
Yale Center for British Art, New Haven, Connecticut

The outlines of this study closely follow those in the
'First Sketch' (Cat.no.3) even in such details as the shape
of the lighted portion of the sky. Although it is not an
exact transcription of that composition in oil, this work
owes a lot to the drawing and probably was executed
shortly after it. It seems likely, therefore, that Ward
painted this study at Gisburn Park, and that it and
perhaps Cat.no.33 were shown to Lord Ribblesdale at
the time and served as the basis for the commission.

33 Oil Study for Gordale Scar (2) [August? 1811]
Oil on canvas
15 × 22 (381 × 558)
Provenance: (?); Briton Riviere[1]; with William Ohly
of the Berkeley Gallery from whom purchased
through the Harding Fund by Temple Newsam,
1942.
Exhibition: Arts Council of Great Britain, *James
Ward*, 1960, No.17; Fitzwilliam Museum,
Cambridge, *Beauty, Horror and Immensity:
Picturesque Landscape in Britain*, 1750-1850, 7 July -
31 August 1981, No.131, illus. pl.61.
Leeds City Art Galleries

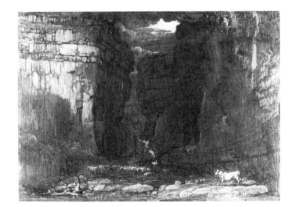

Forms are more clearly defined than they are in the Yale
study (Cat.no.32), and the handling of light begins to
approximate what is found in the final painting. At this
point, only representatives of the Ribblesdale herd of
wild cattle are depicted; there is yet no suggestion of the
deer. Because of the size of this work and its similarity in
scale, concept and technique to the Yale sketch, it seems
likely that this painting was executed soon after the first
oil study, perhaps even when Ward was still at Gisburn
Park. The use of a palette knife for the application of
pigment is especially evident in this and the Mellon
study.

[1] Labels on the back indicate this work was owned by Briton Riviere,
R.A. (1840-1920), an admirer of Ward's work, about 1916.

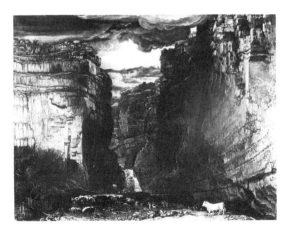

34 Finished Study for Gordale Scar [1811?]-1813
Oil on canvas
30¼ × 40⅛ (768 × 1,019)
Inscribed, lower left: J. Ward [monogram] RA. 1813
Provenance: William Lynn (?); his sale, Christie, 26
May 1843, lot 60 (?); Louis Huth, by 1865; with

Shepherd Brothers, from whom purchased by Bradford, 1904.
Bibliography: *Morning Chronicle,* 10 February 1814, p.3; *New Monthly Magazine,* I, (April 1814), p.280; Julia Frankau, *William Ward, A.R.A., James Ward, R.A.* (London, 1904), p.133 pl.xxvi facing p.270; C. Reginald Grundy, *James Ward, R.A.* (London, 1909), p.44 (No.331); P.A. Tomory, *Foundations of European Art,* (New York, 1969), p.227, illus. p.226; Jeffrey Daniels, 'Dating Gordale Scar', *Country Life,* CLXII, (11 August 1977), p.366.
Exhibition: British Institution, 1814, No.207; British Institution, *Old Masters,* 1865, No.117, lent by Huth; Arts Council, *English Romantic Art,* 1947, No.16 (illus. pl.v); Graves Art Gallery, Sheffield, *Pictures from Yorkshire Galleries,* 1952; Roland, Browse and Delbanco, London, *James Ward and Romantic Painting of His Period,* March 1952, No.2; Boymans Museum, Rotterdam, *Engelse landschapschilders van Gainsborough tot Turner* (British Council), 1955, No.62; Arts Council of Great Britain, *James Ward,* 1960, No.18 (Tate only); Exhibition of British Painting for U.S.S.R., 1960; Cologne, Rome, Zurich and Warsaw, *18th and 19th Century British Painting* (British Council), 1966-7 No.62; Tokyo and Kyoto, *English Landscape Painting of the 18th and 19th Centuries* (British Council), 1970, No.48; Petit Palais, Paris, *La peinture romantique anglaise et les préraphaelites* (British Council), January-April, 1972, No.313; Palazzo Reale, Milan, *British Painting 1660-1840,* 1975, No.99.
Bradford Art Galleries and Museums

Although dated 1813 on completion, this work was undoubtedly in progress from the end of 1811 or the beginning of 1812 as the final step in resolving the composition of the commissioned painting. There is no mention of the study in the Lister Correspondence and it is not recorded in Ward's 'Account Book', which is not a complete listing of his transactions or output from the period. It is highly probable, however, that this painting was purchased by or given to William Lynn (1753-1837), the doctor who treated the artist's family and whose portrait Ward painted in 1819-20.[1] A study for 'Gordale Scar' was put up at the Lynn sale at Christie's in 1843. Because of the description and its prominence in the sale, it seems likely that the Lynn picture was the finished sketch exhibited at the British Institution rather than either Cat.no.32 or 33. While it is possible that the Lynn picture is yet another study, this seems unlikely due to the few other known cases in which Ward created finished sketches for large canvases.[2]

[1] The portrait is in the collection of the Royal College of Surgeons of England, London.
[2] For example: 'Liboya Serpent Seizing Its Prey' (formerly the Collection of the Duke of Sutherland), and 'The Waterloo Allegory - A Finished Study' (Royal Hospital, Chelsea).

35 Gordale Scar [1812?-1814]

Oil on canvas
131 × 166 (3,327 × 4,216)
Provenance: Commissioned by the First Lord Ribblesdale; by descent in the family to the Third Lord Ribblesdale from whose estate it was purchased by the National Gallery, 1878; transferred to the Tate Gallery, 1907.
Bibliography: *Monthly Magazine,* XXXVII, (1 February 1814), p.50; *New Monthly Magazine,* I (March 1814), p.172; *Sporting Magazine,* XLVI, (May 1815), pp.55-6; *The Times,* 6 May 1815, p.3; *New Monthly Magazine,* III (July 1815), p.551; 'Memoir of James Ward, R.A.,' *The Art-Journal,* XI, (1849), p.180; 'Obituary: James Ward, R.A.,' *The Art-Journal,* XXII, (1860), p.9; Henry Ottley, *A Biographical and Critical Dictionary of Recent and Living Painters and Engravers,* (London, 1866), p.172; F. G. Stephens, 'James Ward, R.A.', *The Portfolio,* XVII, (1886), p.45; J. T. Nettleship, *George Morland and the Evolution from Him of Some Later Painters,* (London, 1898), p.59; Sir Walter Gilbey, *Animal Painters of England,* (London, 1900), II, p.238, p.240; James A. Manson, *Sir Edwin Landseer, R.A.,* (London, 1902), pp.7-8; Julia Frankau, *William Ward, A.R.A., James Ward, R.A.,* (London, 1904), p.128; C. Reginald Grundy, *James Ward, R.A.,* (London, 1909), p.xxxvi. 44 (No.330); Christopher Hussey, *The Picturesque: Studies in a Point of View,* (1927; rpt. Hamden, Conn. 1967), p.109 note, p.270; John Piper, *British Romantic Artists,* (London, 1932), illus. p.10; R. H. Wilenski, *English Painting,* (London, 1933), p.162; Walter Shaw Sparrow, 'The Versatility of James Ward', *Connoisseur,* XCVII, (1936), p.3; C. Reginald Grundy and F. Gordon Roe, *A Catalogue of the Collection of Frederick John Nettleford,* (London, 1938), IV, p.99, p.101; Geoffrey Grigson, 'James Ward Reconsidered', *Country Life,* CVII, (13 January 1950), p.97, illus. p.96; H. L. Bradfer-Lawrence, 'A Painting by James Ward', *Country Life,* CVIII, (3 November 1950), p.1508; Prudence Summerhayes, 'An Artist's Account Book', *Connoisseur Yearbook,* (1959), p.53, p.55; Robert Rosenblum, 'The Abstract Sublime', *Art News,* 59, (February 1961), p.40, illus. p.38; John Woodward, *British Painting,* (London, 1962), p.94, illus.; William Gaunt, *A Concise History of English Painting,* (London, 1964), p.152; J. T. Boulton, 'Introduction', to Edmund Burke's *A Philosophical Enquiry into the Origin of Our Ideas of the Sublime and Beautiful,* (Notre Dame and London, 1968), p.cxiii; P. A. Tomory, *Foundations of European Art,* (New York, 1969), pp.227-8; Stella A. Walker, *Sporting Art England 1700-1900,* (New York, 1972), p.72; G. E. Fussell, *James Ward, R.A.,* (London, 1974), pp.106-7; Prudence Summerhayes, 'Great Picture in Obscurity: James Ward R.A. and *Gordale Scar*', *Country Life,* CLXII, (21 July 1977), pp.154-5,

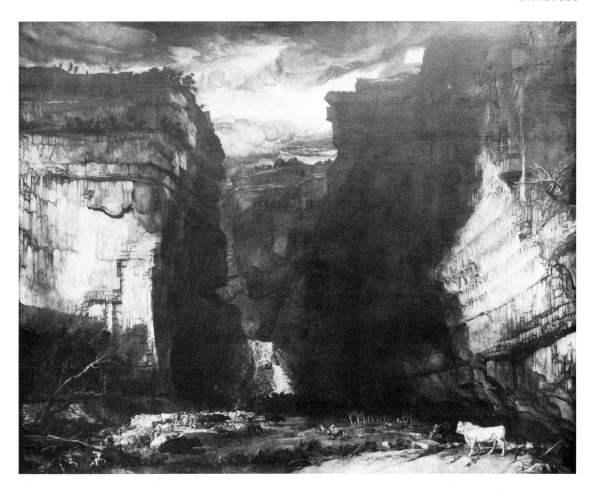

illus. p.154; Jeffrey Daniels, 'Dating Gordale Scar',
Country Life, CLXII, (11 August 1977), p.366; Hugh
Honor, *Romanticism*, (New York, 1979), pp.112-13,
illus.p.113; Gerald Finley, 'The Genesis of Turner's
"Landscape Sublime" ', *Zeitschrift für
Kunst-Geschichte*, 42, (1979), p.162-3, illus. p.155;
Andrew Wilton, *Turner and the Sublime*, (London,
1980), p.45, 124; Peter Bicknell, *Beauty, Horror and
Immensity: Picturesque Landscape in Britain*,
1750-1850, (Cambridge, 1981), p.xiv.
Exhibition: Royal Academy, 1815, No.255; Arts
Council, *The Romantic Movement*, July-September
1959, No.369; Arts Council of Great Britain, *James
Ward*, 1960, No.19 (Tate only).
Tate Gallery (1043)

In view of Ward's other commitments, the state of his
health early in 1812, and his unwillingness to show
Thomas Lister the painting in May of the same year,[1] it
seems unlikely that work was begun on the final version
before 1812 or had progressed very far by late spring.
Newspaper reports in February of 1814 speak of the
work as completed,[2] but it is probable that Ward made
some changes especially after the less than favourable
response to the finished study when it was exhibited at
the British Institution in 1814.

[1] See 'Chronology', 30 January, 13 February, and 15 May, 1812.
[2] See 'Appendix I', for the remarks in *The Morning Chronicle*, 10
February 1814.

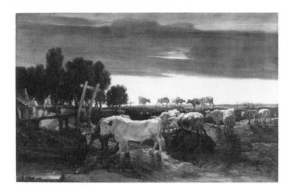

36 Cattle-piece,? Marylebone Park

(A Cow-Layer: Evening after Rain) 1807
Oil on canvas
$29\frac{1}{2} \times 47$ (750 × 1,194)
Inscribed, lower right: J Ward [monogram] 1807
Provenance: (?); bequeathed by Elizabeth Vaughan
to the National Gallery, 1885; transferred to the Tate
Gallery, 1919.
Bibliography: F. G. Stephens, 'James Ward', *The
Portfolio*, XVII, (1886), illus. facing p.12; J. T. Nettle-
ship, *George Morland and the Evolution from Him of
Some Later Paintings*, (London, 1898), p.55; Sir
Walter Gilbey, *Animal Painters of England*, (London,
1900), II, p.238; C. Reginald Grundy, *James Ward,
R.A.*, (London, 1909), p.48 (No.527); William
Whitley, *Art in England 1800–1820*, (Cambridge,
1928), p.130, illus. facing p.166; Walter Shaw
Sparrow, *A Book of Sporting Painters*, (London, 1931),
p.82 note, illus.; R. H. Wilenski, *English Painting*,
(London, 1933), p.162; C. H. Collins Baker and
M. R. James, *British Painting*, (London, 1933), p.134;
Walter Shaw Sparrow, 'The Versatility of James
Ward, R.A.', *Connoisseur*, XCVII, (1936), pp.3–4,
illus. p.5; Stella A. Walker, *Sporting Art England
1700–1900*, (New York, 1972), p.165.
Exhibition: Royal Academy, 1808, No.354 (?); Arts
Council of Great Britain, *James Ward*, 1960, No.8.
Tate Gallery (1175)

Although recently retitled 'Cattle-piece? Marylebone
Park', 'Regent's Park' is the traditional title for this
painting. In 1933, R. H. Wilenski pointed out that the
titled was an anachronism since Regent's Park was
actually Marylebone Park when this work was executed.[1]
However, although the area contained the largest farm in
the country at the time,[2] there is no conclusive evidence
that the locale portrayed here is actually Marylebone or
Regent's Park.

It has been suggested that this work might well be one
of several landscapes or cattle pieces Ward exhibited at
the Royal Academy in 1807 and 1808,[3] but no one has
yet proposed 'A Cow-Layer: Evening after Rain', shown
at the Academy in 1808 (no.354). Despite the lack of
contemporary descriptions for 'A Cow-Layer', the
painting under discussion seems a likely candidate. The
area portrayed is indeed a cow-layer; that is, a separate
field or layer below the normal level of the surrounding
land where cattle are kept. Moreover, the striking band
of yellow in the sky and strong shadows declare the time
of day as evening while the breaking storm clouds reveal
it has just rained.

The bold handling of *chiaroscuro* and pictorial interest
in the treatment of evening undoubtedly grew out of
Ward's study of Rembrandt. The year before, in 1806,
he had painted a picture in imitation of the Dutch
master's 'The Mill', in which these lighting effects were
explored.[4] 'A Cow-Layer' further extends Ward's

concern with the dramatic use of light for which Rembrandt was greatly admired at the time.

Two studies for the work are known but provide no clue as to its original title. The white bull, clearly the same animal portrayed in Cat.no.30, also appears in a painting called 'The Great Bull' (Winnipeg Art Gallery).

1 R. H. Wilenski, *English Painting*, (London, 1933), p.162.
2 G. E. Fussell, *James Ward*, R.A., (London, 1974), p.34.
3 Arts Council of Great Britain, *James Ward*, 1960, No.8.
4 Called 'Ashbourne Mill', the painting is in a private collection, U.S.A. 'The Mill' (National Gallery, Washington) has been questioned as a Rembrandt, however, the picture was accepted as the master's work in the early nineteenth century and recent scholarship supports its authenticity.

37 Tabley Lake and Tower [1813?–1818] 1814
Oil on canvas
37 × 53½ (940 × 1,360)
Inscribed, lower left: J Ward [monogram] RA 1814.
Provenance: Commissioned by Sir John Leicester (1st Lord de Tabley); his sale, Christie, 7 July 1827, lot 38, bought by Robert Vernon, who gave it to the National Gallery, 1847; transferred to the Tate Gallery, 1929.
Bibliography: *Monthly Magazine*, XXXVII, (February 1814), p.50; John Young, *A Catalogue of Pictures by British Artists in the Possession of Sir John Fleming Leicester*, (London, 1821), p.19 (No.44), illus. facing p.20; *Art Union*, 1 November 1847, p.367; 'Memoir of James Ward, R.A.', *The Art-Journal*, XI, (1849), p.180; G. F. Waagen, *Treasures of Art in Great Britain*, (London, 1854), I, p.382; *The Atheneum*, 19 November 1859, p.671; 'Obituary: James Ward, R.A.', *The Art-Journal*, XXII, (1860), p.9; Henry Ottley, *A Biographical and Critical Dictionary of Recent and Living Painters and Engravers*, (London, 1866), p.172; C. Reginald Grundy, *James Ward, R.A.*, (London, 1909), p.53 (No.826); Walter Shaw Sparrow, 'The Versatility of James Ward, R.A.', *Connoisseur*, XCVII, (1936), p.6, illus. p.7; Douglas Hall, 'The Tabley House Papers', *Walpole Society*, XXXVIII, (1960–62), pp.95–96; John Sunderland, *Painting in Britain 1525–1975*, (Oxford, 1976), pp.246, 247, 249, illus. pl.117; Hugh Honor, *Romanticism*, (New York, 1979), p.112.
Exhibition: Tate Gallery, *Landscape in Britain c.1750–1850*, 1973, No.219.
Tate Gallery (385)

Although inscribed 1814, the painting was begun no later than 1813 since the letter describing the almost finished work is dated 7 January.[1] There are also sketches of the lake and cattle from the summer of 1811 when Ward visited Tabley Park on his way to and from Gordale. Sir John Leicester was not satisfied with the

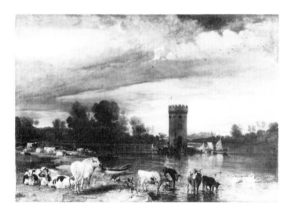

picture, and Ward eventually retouched part of it in 1817 or 1818, for which he received an additional 50 guineas above the original payment of £100.[2]

From the correspondence, it seems clear that Ward eliminated a shepherd and probably changed the foliage near the Tower, which his patron found stiff and formal. But the bull, which is so integral to the composition, may also have been a problem. In his letter, Ward explained the bold foreshortening of the animal. Since the foreshortening in the present painting does not appear unusual, it seem reasonable to conclude that the artist may have altered this passage as well. X-ray photographs would be useful in determining the original composition and the extent of the changes made.

1 Douglas Hall, 'The Tabley House Papers', *Walpole Society*, XXXVIII (1960–62), pp.95–6.
2 *Ibid.*, p.96; also: James Ward, 'Diary', 11 March 1818, MSS, Collection of Mme E. Arnold, Geneva.

APPENDIX I

I[a]

I February 1814 , *Monthly Magazine,* 'Varieties, Literary and Philosophical (Vol.37; No.251; p.50)

'Among the successors of the first English school, the name of Ward stands conspicuous for the originality of his style, the boldness of his conceptions, and his successful delineation of nature. He has been compared to Sneyders, and to Rubens, but the comparison is irrelevant, except as a parallel of merit; for his manner is all his own, and he is as original as either of those great painters, while his pictures as completely satisfy the eye of taste. Nor is his genius limited to animals, in which he has so powerfully and confessedly excelled; for we have seen a portrait of his, which reminded us of Rembrandt; and an historical piece not unequal to the best manner of Titian. The landscapes in which he places his animals are, as is well known, unequalled for force, justness of colouring, and variety of expression; and are exceeded by nothing of their kind in any modern school. It improves our opinion of the age to find his pencil fully employed, and upon subjects which are worthy of his rare powers. For example, he has recently finished a picture for LORD RIBBLESDALE, which we think, will rank as his master-piece, and which can scarcely fail to be the chief ornament of the next exhibition at Somerset-house. It is at once wonderful as a superior work of art, and wonder-working in its effect on the mind of spectators. It represents a vast dell formed by perpindicular cliffs of limestone strata, at a place called Gordale Scar, near Skipton, in Yorkshire. A chasm in the rocks, down which falls a cascade, enlightens the gloom on a plain at the bottom, on which Mr. Ward has introduced groups of wild animals peculiar to the country, and among others his favourite, the bull. These give the desired effect to the enormous cliffs, and we doubt whether a more perfect presentation of the *vast* in nature, was ever produced on canvas. This picture is fourteen feet high, by eleven wide' (The article goes on to discuss other works by Ward, including 'a rich and pleasing view of Tabley Tower, in the park of Sir John Leicester, in Cheshire.')

I[b]

10 February 1814, *The Morning Chronicle,* 'Fine Arts' (No.13, 968; p.3; col.3)

'No. 207. *Gordale,* by James Ward, R.A. – We imagine the subject of the picture is essentially defective, as it is an attempt to express physical magnitude by contrast, which can only be done by distance. The figures and animals look diminutive and contemptible without making the surrounding scenery look grand or lofty. The same effect is in some degree produced even in nature, and much more in a picture.'

I[c]

March 1814, *New Monthly Magazine,* 'Intelligence'
(Vol.1; No.2; p.172)

'Mr. Ward has also [in addition to copying Titian's *Diana and Actaeon*[1]] painted a magnificent picture for Lord Ribblesdale. The subject is a natural amphitheatre on his lordship's estate in Yorkshire, called Gordale-scar. The picture is nearly twenty feet in length, and about fifteen in height. The scene is awfully grand and the effect sublime. Mr. Ward has in the subject displayed his powers of portraying animal nature, as large herds of oxen are seen on one part, and of deer on the other. A fine episode is introduced of two of the latter animals fighting with the utmost animosity.'

[1] This work is in the Calouste Gulbenkian Foundation Museum, Lisbon.

I[d]

April 1814, *New Monthly Magazine,* 'Review and Register of the Fine Arts'
(Vol.1; No.3; p.280)

'No. 207. Gordale, a finished sketch for a large picture for the Right Hon. Lord Ribblesdale – James Ward, R.A.
 'This is a view of the most extraordinary natural amphitheatre, which from the majestic manner in which Mr. Ward has treated it, makes us long to see the "large picture." A few rude figures of banditti or shepherds would render it a fine composition in the grand style of Salvator Rosa.'

I[e]

May 1815, *The Sporting Magazine,* 'Sporting Subjects, Animals, &: Observations'
(Vol.46; No.272; pp.55–56)

'No. 255. *A View of Gordale, in the Manor of East Malham in Craven, Yorkshire, the property of Lord Ribblesdale.* – By J. Ward, R.A. – If any body of taste and judgement can bring his mind to admire this, or any part of this coarse, dark, ostrogothic piece of mosaic-painting, we give him joy, but will not envy him, or ever partake of, his pleasure.'

I[f]

6 May 1815. *The Times,* 'The Arts'
(p.3; col.c)

'Mr. Ward, who has no equal in the present day, as a painter of quadrupeds, has introduced groups of them with his usual knowledge of nature, in a scene which is not executed with equal felicity; it struck us as having the appearance of an high-wrought tapestry.'

I[g]

July 1815, *New Monthly Magazine,* 'Exhibition of the Royal Academy'
(Vol.3; No.18; p.551)

'Nos. 148, 168, 300 by J. Ward, Esq.R.A. are Animals. 168 Portraits of a charger and a favourite poney, the Property of Lord Stewart, is everything, we think, that can be wished for in this branch of the art: the colouring is excellent, and forcibly reminds us of Titian. – 255, A View of Gordale, in the Manor of East Malham, Craven, Yorkshire, the Property of Lord Ribblesdale. This immense picture is a strong proof of Mr. Ward's mechanical skill in art, but we are not satisfied with it. From the general blackness and want of air in the picture, there is a want of magnitude, notwithstanding the vast scale upon which the objects are represented; and remembering, as we do, the striking solemnity and deep solitude of Gordale, where not a living thing was seen to disturb the profound sentiment of awe and astonishment that overwhelmed us, we were surprised at perceiving Mr. Ward had introduced – we had almost said – a cattle fair.'

Notes for Appendix II opposite

[1] Lister Correspondence, Bradfer-Lawrence Collection, MD.335, Yorkshire Archaeological Society. Published with the permission of the Yorkshire Archaeological Society, Leeds.
[2] Not dated, the letter was clearly written toward the end of July, shortly before the Honourable Thomas Lister wrote to his father, Lord Ribblesdale, about the painting (see Chronology: 27 July, 1815).

Appendix II[1]

Frid[y]. N[t].[2]

My dear L, [Lord Ribblesdale]

I am just returned from G.P. – and never felt so strongly the Powers of Art. – Gordale is safely placed in the Stretching Frame without having sustained the least damage on its precarious Traverse. – It is indeed a most sublime and awful Picture. The Effect of seeing a strong Burst of Light upon the dark and lofty Mass of the projecting and receding Rocks on each side the Chasm exceeds wonderfully any Idea I ever entertained of Colouring, and the whole Composition of this Part is magically heightened by the rolling Passage of the tremendous clouds above such vast and lofty Scenery. – The Foreground too is admirably depicted and the Light again is masterly diffused over the beautiful Imagery before you.

There appears to be nothing frippery nor unnaturally botanical about such a sequestered and unfrequented Vale, but at the same time this Part is more highly as well as more beautifully finished than the Effort of any other Artist I ever saw since Rubens.

Wards name I have heard you both say stands high and chiefly so for his Figures & especially Cattle. If it be so, excepting the Wild Bull, He has chosen the worst Species of y[e] Animals I can conceive – but a Mans Mind I sh[d] think must be fastidiously induced to look after Defects to have his Delight and indeed Extacy [sic] checked by dwelling for a moment on minor Points when the grand features in View disclose both Ingenium Studiumque cum Divite Vena.

Such are the real feelings and Impressions which a first Purview of this magnificent Production has left upon my Imagination.

It is of great Misfortune that there is not a Situation for it. – There are but Two Places where it can possibly be hung or can be made capable of being fitly seen – and to one there is almost insurmountable Objection – the East Side of the Drawing Room – but here, the size and Grandeur of this Colossal Canvas and its massive Frame w[d] totally overpower all the softer Tints of the more elegant Landscapes and Paintings in the Room.

The other Situation is in Y[r] Lordships Room – and this is only subject to one Inconvenience, but which I think for such Purposes as that Apartment is appropriated, namely a retired Library, by no means creates so strong an Objection as to prevent its Adoption for so very desirable an Attainment. – It cannot hang for want of six inches without blocking up the present Entrance into the Hall – This will be alleviated if not removed by a more private Door into the Staircase.

In this Situation, Gordale w[d] be viewed in its native Majesty from the Arcade, and approached as it ought to be with Awe and a kind of reverential Expectation towards this Masterpiece of Natures Wonders. –

Robinson is for a New Dining Room. – 'If not, this is only Room or Place that can be made capable of containing it, and the Ceiling here may be adapted at little Trouble or Expence'.

So far my dear L have you the Opinion of a Candid however inadequate a Critic. – You know my own Sentiments of M[r] Wards Abilities were not most favourably prejudiced, and I perhaps feel the more gratified in consequence of having previously been suspicious His Powers were altogether inadequate to sublime an Imitation.

Adieu Ever Y[r]
T.C.
[Thomas Collins]

APPENDIX III[1]

'Gordale Scar', by James Ward, R.A.

The report of the Director of the National Gallery for the year 1878, issued in March, 1879, mentioned that the picture of 'Gordale Scar', by the late James Ward, R.A., had been purchased out of the Government grant for the large sum of £1,500. Surprise was expressed at the time at the purchase of a work which, though no doubt typical of the English school of the early part of the century, still is by an artist already represented by a canvas of large dimensions, and besides had the objection which had been fatal to so many pictures, namely, its enormous size. This surprise will be immeasurably increased when the following facts are known:

1 That 'Gordale Scar' was given to the National Gallery in the year 1830.
2 That from that year, until the year 1857, it lay in the cellars of the British Museum.
3 That in the year 1857 the gift was returned to the representatives of the donor, he having meanwhile died.
4 That five years afterward the Director of the National Gallery purchased for £1,500 of the artist[2] a picture, 'The Bull, Cow and Calf' in no degree more representative of the artist's work than the one which had been given to them, kept by them for twenty-seven years, and then returned.
5 That the picture of 'Gordale Scar' was refused, in spite of the earnest and long-continued appeals from the artist.

The correspondence from which these facts have been elicited begins so far back as the year 1840, when Mr Ward endeavoured to obtain the decision of the Governors of the British Museum, in whose charge 'Gordale Scar' then was, as to their designs with reference to it. Their answer was that the gift of the picture had been resumed by the donor's (the late Lord Ribblesdale's) representatives, it being impossible to find a suitable place in the Museum for it. But this can hardly have been the case, for the correspondence, which continued at intervals for seventeen years, shows that the picture was then, and for many years afterwards, at the Museum.

The following characteristic and touching account of the transaction, contained in a letter from the artist, then in his eighty-eighth year, to his son, Mr G. R. Ward, narrates all the circumstances of the case:

<div style="text-align: right">

Round Croft,
January 22, 1857.

</div>

Dear George,

'Gordale Scar' was painted in 1812, size 11 feet by 14 feet; I know not what I had for it. It was for the father, who took me to see the place, telling me that Sir George Beaumont had seen it, and pronounced it an impossibility to paint it, and which led to his giving me the commission, intending to build a large new house to put it in; but he died very soon, and his son told me he should content himself with Gisbourne [sic] Park, therefore had not a room large enough to show it; besides, he thought such a work should not be shut up in a little corner of Craven, and if I approved of it, he would present it for the intentional National Gallery, in order of [?] which he would send it to the British Museum, to be hung up there until the National Gallery was ready and then to be <deposi>ted there as a national picture. The British Museum on opening it was, I believe disappointed, expecting it to be my large

cattle work; and being sent to them as not their own picture, it was not likely they would put themselves to inconvenience in hanging it up, and when I saw it, it was rolled up in its case in the entrance hall of the British Museum. The young Lord Ribblesdale very soon died suddenly, and no one was left to look after it and give particulars, and like my three greatest works, hid from the public eye.[3] This is what the world would call my *ill luck*, but I endeavour to view it as a Providence, in order to keep me humble, who have always been too greedy of admiration and praise, instead of making money, and am now in a state of extreme age and as extreme pain and feebleness, with the feeling of living above my income, without the power of making a shilling to help me, with every one supposing me to be a rich man beyond that which is the fact I am in constant pain more or less, in body as well as mind; feel weaker and weaker; the thought of eating anything only appears to disgust me, and now have a cough, with soreness at the stomach. My eyes and head are affected, and I only long for sleep. You may suppose that your dear mother is under all this suffering. I look back and around upon all my laborious and successful exertions through a long, long life, as to its reward, only as so much *trash*, and the *Fine Arts* as having a sort of curse hanging over it, reminding me of a passage in the Bible, 'Thou shalt destroy all their images and all their pictures.' For it is an accursed thing, and all history, more or less, has proved that fact, and I would wish you and every one dear to me was in anything else than the Arts. There ought to be no such thing as fashion in the Fine Arts, but we find success in very little else. This is the testimony of one who has struggled, and successfully, thriving almost one hundred years in the confusion and worst of it, and now leaves me in poverty and gloom!!! I could write long, long, and much upon this subject, but have not strength and inclination to repace the dirty road. I wish I could state that your poor dear mother is as much better as I could wish; but what is to be expected when everything we read or hear all round us is filled with gloom. She desires love to you all, with

<div style="text-align:center">

Your affectionate Father,
[Signed] James Ward

</div>

P.S. – If you could find any other way of getting a living I should rejoice at it; anything to get out of the rattlesnake list of the Fine Arts.

On receiving that letter, Mr G. R. Ward wrote, on the 31 January, 1857, to Signor Panizzi, the Librarian of the British Museum, a letter which, after stating the facts, went on to say:

This picture was accepted by the trustees and unrolled, my father and the late lord being present, if I remember rightly. It was again rolled up and placed in the box in the entrance hall, where it remained for upwards of twenty years until the new portico was added, and it is only within the last few days I have learnt, through the kind inquiries of Mr Hawkins, that it is placed in a cellar, in all probability a damp one: and as it is upwards of thirty, if not thirty-five, years since its presentation, I greatly fear the painting is ruined. Some years back I wrote to the trustees, but the documents have been mislaid, and the death of Lord and Lady Ribblesdale created some difficulty; but as I trust it is not the desire of the trustees that so fine a work of Art should never see the light and thus be ruined, I trouble you with this note to solicit your bringing the matter before that body at the next meeting, as I am desirous to learn whether they will hang up the picture or offer it to the Director of the National Gallery, whom I have already seen on the subject, and who is ready to act on the occasion should the trustees require him. As it is most important that the state of the painting should be ascertained, and its speedy removal from its present damp situation, and as I feel warmly

interested in the subject, my father being in his eighty-eighth year I should be glad to be permitted to be present when it is unrolled, and which must be done with great caution after being shut up so many years.

Not having received an official reply, Mr Ward wrote again on the 6 October, 1858, as follows:

<div align="right">

38 Fitzroy Square,
October 6, 1858

</div>

Sir,

On the 31st of January, 1857, I addressed you a letter on the subject of my father's great picture, presented by the late Lord Ribblesdale to the British Museum, which had then been consigned for some years to a cellar. Thirty-five years had then expired since its presentation and since it had been unrolled. You kindly wrote you had submitted my letter to the Board of Trustees, who had referred it to their sub-committee on Antiquities and Fine Arts, and that you hoped shortly to be able to give me their decision upon it. As a year and nine months have now elapsed, I trust I shall not be considered importunate in asking for their decision, particularly as my father this month enters his ninetieth year, and feels not a little anxiety on the subject.

<div align="center">

I have the honour to be,
&c. &c.

</div>

Signor Panizzi

And received this reply:

<div align="right">

British Museum,
7th October, 1858

</div>

Sir,

I have to acknowledge the receipt of your letter of the 6th inst., respecting your father's picture lately at the British Museum, and beg to refer you to my communication of the 19th of March, 1857, in which I acquainted you that I had informed Lord Ribblesdale, to whom the picture in question belonged, of your request, and that his lordship would probably have the painting removed elsewhere, and then deal with your application as he might deem fit. I have now to inform you that the case containing the picture was, by his lordship's direction, forwarded, on the 7th April, 1857, to Gisbourne Park, Blackbourne, Lancashire, so that you will see his lordship is the proper person to apply to for any further information on the subject of your letter.

<div align="center">

I am, Sir,
Your very obedient Servant,
[Signed] A. Panizzi
Principal Libarian

</div>

The correspondence may well close with the following letter, showing that the nation have spent £3,000 in obtaining specimens of Mr Ward's work, when they need have spent none, and with an extract from a weekly paper taken up whilst putting together these notes.

38 Fitzroy Square, W.
1st September, 1862

Dear Sir,

I have reconsidered your letter of the 30th of August. I have so great a desire to see my father's *chef-d'oeuvre* in the national collection that I shall not hesitate (for this reason) to accept the offer made by the trustees of £1,500 for his great work of cattle, 'The Bull, Cow, and Calf,' knowing that it will be the highest gratification of his friends and family to see this wonderful work in the national collection.

I am,
Dear Sir,
Yours faithfully,
[Signed] G.R. Ward

W.R. Wornum, Esq.

'Our National Gallery seems to go on upon the makeshift principle. Some ten years back we were treated to a wonderful exhibition of designs for a new gallery, in which all the talents of the architectural world were displayed in competition, and nothing came of it, though the premiums for the best and the second best were awarded and paid. The land had been bought and the ground cleared but all that has been done to make a new and proper gallery has been to add on rooms behind the present building. Every room is full, and most of the Turner drawings are kept in the crypt, while the Raphael cartoons and many other fine things are obliged to remain in another place for want of space. The answer to anxious inquiries is: "We've got no money to go on with, and we can't buy any more pictures till we have room for them." This would be a rational excuse for a private collector, but it is a ridiculous one for a nation. How is it that France, with her enormous debt to pay off, and Germany, with the tremendous calls for her million of soldiers, can go on purchasing all the best things that are to be had, while England is losing her "ascendancy" in the market of Fine Arts more and more every day? It is admitted that the opportunities are getting more rare, yet while other directors of galleries abroad are always on the look-out, ours seem to be asleep.'

NOTES

[1] The following reproduces the text taken from a damaged proof sheet of an anonymous undated article, Summerhayes Collection. The article must date after March of 1879 when the report of the National Gallery was published. It is possible that the article was never published although criticism of the purchase was reportedly voiced in *Truth*, a periodical. A letter to this effect, dated 7 August 1880, and addressed to Mr Burton, is in the object file at the Tate. A search of the magazine for 1879 and 1880 proved fruitless.

[2] The painting 'Group of Cattle' (or, 'Bull, Cow and Calf' as it is referred to in this article) was sold by George R. Ward, the artist's son, and not by the artist. Also called 'Protection', it is in the Tate Gallery.

[3] One of these was definitely 'The Waterloo Allegory', for which there is a large finished sketch at the Royal Hospital, Chelsea. The other two probably were 'Group of Cattle' (see note 2 above) and perhaps either the finished version of 'Liboya Serpent' (unlocated) or 'The Pool of Bethesda' (unlocated).

LIST OF LENDERS

Madame E. Arnold 2, 8
Bradford Art Galleries and Museums 34
Peter Cochrane 29
Courtauld Institute Galleries 21
Fitzwilliam Museum 14, 24
Douglas Gordon 9
Leeds City Art Galleries 33
Paul Mellon Collection 17, 19
Private Collection, 11, 13, 18, 25, 28, 30
Anthony Reed 1, 10, 15, 27
Mrs Eva Sanderson 4
Prudence Summerhayes 3, 6, 7, 22, 23
Tate Gallery 5, 12, 26, 35, 36, 37
Mr Claude Werner 16, 20
Wolverhampton Art Gallery and Museums 31
Yale Center for British Art 32